Julia Margaret Cameron

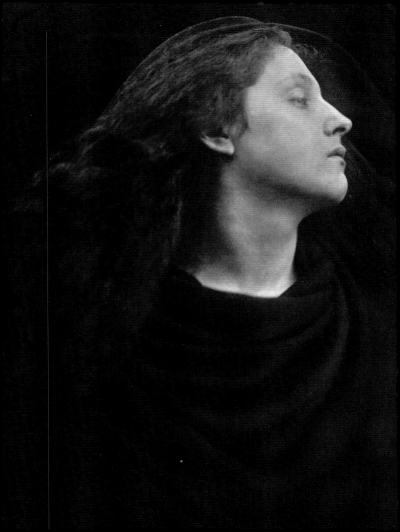

Julia Margaret Cameron

Virginia Woolf

Julia Margaret Cameron

Roger Fry

Introduction by
Tristram Powell

The J. Paul Getty Museum, Los Angeles

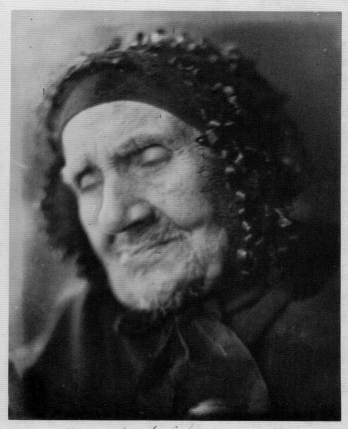

aged 94
Taken on the Anniversary
of her 72d Wedding day

CONTENTS

Opposite: Sarah Groves, 'Aged 94, Taken on the Anniversary of her 72nd Wedding day', 1865

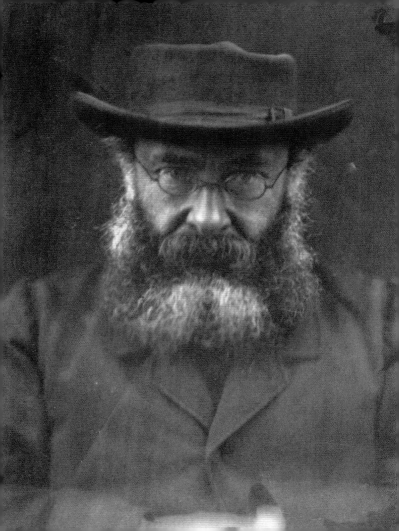

INTRODUCTION

TRISTRAM POWELL

Julia Margaret Cameron showed how, since its begin-
nings, the camera has loved fame and 'fair women'. So
no change there with today. She had excellent contacts
amongst the well-known writers and painters of her age.
Her good-looking family (and housemaids) could be
bullied into sitting for the lengthy exposures. At forty-
eight she had the time and resources to pursue her hobby
in a period when the demarcation between professional
and amateur was not so clearly defined as today. And, as
a woman, she was working in a new medium, which was
not necessarily assumed to be the prerogative of men.

It was the age of amateur theatricals, country-house
charades and the *tableau vivant*. The dressing-up box
could be raided to create for the camera characters from
the Bible or allegorical scenes – some of Cameron's dis-
tinctly less successful efforts at photographic 'art'. Hu-
mour is never far away for them, as for us. Her portraits
are artificial, not manipulated, but needing many tedi-
ous attempts, aiming to mirror character regardless of

Opposite: Anthony Trollope, 1864

technical perfection, the fetish of today's camera-makers. She was in awe of these great men and their brooding intellects. In her wonderful portraits of her old friend Sir John Herschel, himself a pioneer of early photographic techniques, the startling halo round freshly washed hair is almost visible. With her men there is awe, with her women intimacy.

In 1971 I put together a small exhibition of Cameron's work at Leighton House in London. I was then asked to edit a revised edition of Virginia Woolf's study of her great-aunt's photographs. It was originally published by the Hogarth Press in 1926 – in its own way a pioneering photo-book. The essays by Virginia Woolf and Roger Fry took Cameron's work as seriously, almost, as she did herself. She always inscribed her photographs and regarded them as works of art. Those that have been kept out of the light have become enormously valuable. My own souvenir from the exhibition is inscribed *A study of Alice Liddell, 1872, from the registered photograph copyright*. She has also written *Alethea* (Truth) underneath the picture. It's very faded, but I like it that way. Cameron's Alice, so very far from Lewis Carroll's winsome 'Beggar Girl', is a modern young woman. Even more so is Julia Duckworth, mother of Virginia Woolf and

Opposite: A study of Alice Liddell, 'Alethea', 1872

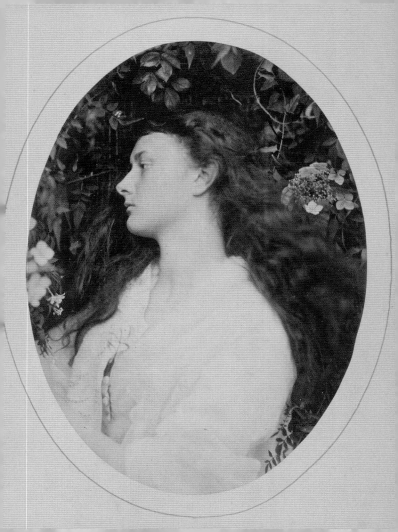

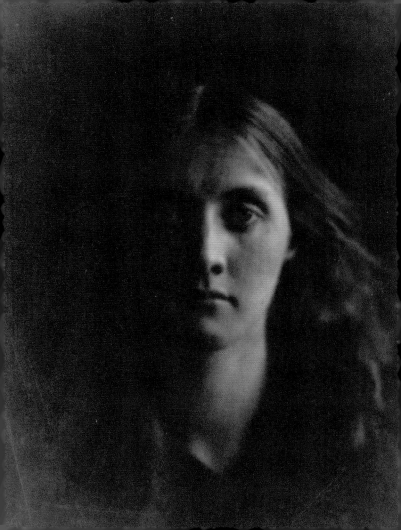

Vanessa Bell. And so are her other portraits of women that have escaped their rigid, idealistic, painted stereotypes. Poised between generations, with her new hobby, full of the confidence of class, Cameron, in her best work, broke all the old rules of art and allowed the new medium to dictate what appealed to her own eye.

Although England and Scotland had their photographic historians and pioneer practitioners it was not until the 1970s, trailing far behind America, that photography took off in this country. Suddenly photographs had commercial and æsthetic value. Galleries, museums, auction houses, books and magazines, university art departments, the Arts Council, all got in on the act. And so it has continued into our own digital age, when we make things real by taking a quick photograph, which may be passed around in the virtual, unreal world. No need to print it. What have we gained? What have we lost? It would certainly have been more exciting to be photographed by Julia Margaret Cameron, the drama behind the camera as great as in front of it. 'Dressed in dark clothes stained with chemicals and smelling of them too, with a plump, eager face and piercing eyes and a voice husky and a little harsh, yet in some way compelling and even charming.'

*　　*　　*

Opposite: Julia Jackson (later Duckworth) ('La Santa Julia'), 1867

Victorian Photographs of Famous Men and Fair Women by Julia Margaret Cameron was first published in 1926. The book contained Virginia Woolf's entertaining account of her great aunt, and Roger Fry's analysis of Mrs. Cameron's photographs which was well ahead of its time in appreciating some of the virtues of photography. The book reproduced 24 studies (plates 1-24 in this edition), some of which Fry commented on in detail. The present edition has added 26 further photographs to the plate section, together with some images in the text.

Mrs. Cameron recorded her first successful photograph in 1864 when she was forty-nine. Photography proved to be the perfect outlet for her talents, part artistic, part social, and from that date until her death in Ceylon in 1879, she persuaded or commanded family, friends, servants, the famous, or just passers-by whom she spotted from her window, to pose before her camera.

In 1874, she wrote a biographical fragment, 'Annals of My Glass House', in which, with characteristic emotion, she describes her early struggles. She had been given a camera by her daughter, with the simple words, 'It may amuse you, Mother, to try to photograph during your solitude at Freshwater.'

> The gift from those I loved so tenderly added more and more impulse to my deeply seated love

of the beautiful, and from the first moment I handled my lens with a tender ardour, and it has become to me as a living thing, with voice and memory and creative vigour.

'I longed to arrest all beauty that came before me,' she continued, 'and at length the longing has been satisfied.' It was not, however, by her eventual mastery of the – immense – technical difficulties, but by an entirely æsthetic discovery:

> I believe that what my youngest boy, Henry Herschel, who is now himself a very remarkable photographer, told me is quite true – that my first successes in my out-of-focus pictures were a fluke. That is to say, that when focusing and coming to something which, to my eye, was very beautiful, I stopped there instead of screwing on the lens to the more definite focus which all other photographers insist upon.

Although she began as an amateur, Mrs. Cameron ended up a self-conscious artist. She quickly realized that the chancy out-of-focus effect, which became her hallmark, whether a fluke or not, could establish the beauty of a print. She would make many versions of a print to reach a precise effect (the head of Mrs. Herbert Duckworth for example), and if she was sometimes haphazard

in the application of chemicals, she also knew that technical flaws in reproduction meant nothing if the mood and character of the picture were right. She did not believe in retouching. 'From life, registered photograph' would generally be written on the mount, together with her signature and the date. She had, in fact, a strong sense of the originality and value of her work.

The force of personality which strikes us in her best pictures, combined with her choice of subject, has given her work a coherence which is lacking in less personal photographers. An intensity of feeling is transmitted to the sitter and one has only to compare her pictures with conventional studio photographs of the period to see how uninhibited she was and how differently she reacted to each of her sitters. Her portraits of famous men do, it is true, enshrine a monumental view of human personality. Mrs. Cameron believed that great thoughts shone, like haloes, from the heads of her thinkers, so her pictures are acts of homage towards her heroes. She would not allow a word of criticism of the roles in life which her sitters had assumed, or which she had imposed on them for the length of the photograph. And indeed she never really forgave the poet William Allingham for not being wholly enthusiastic about the verse of her friend, the much photographed Sir Henry Taylor, whom she worshipped.

William Allingham clearly found Mrs. Cameron's commanding manner and eccentricities, however genuine, rather irritating. When Rossetti came to stay with Allingham at Freshwater Bay, several pressing notes arrived inviting them both over to be photographed. The answer was decidedly 'No.' Edward Lear also failed to make friends with Mrs. Cameron. 'Mrs. Cameron only came in once – with feminine perception not delighting in your humble servant,' Lear wrote to Holman Hunt after a visit to the Tennysons. 'We jarred and sparred and she came no more.' Not everyone fell for Mrs. Cameron's charm.

No other early photographer, except perhaps Fox-Talbot, has conveyed so clearly the excitement of experimenting with the camera, and the attempt to make full use of the characteristics inherent in what must have seemed a magical new medium. The wistful air which hangs over many of her photographic portraits is like a last look back to the days of the painted portrait, a last attempt to transmit the aura of the great figures of the time by the medium which was turning painting upside down. Her camera, and those of a few other early photographers, signal the decline of portrait painting as straightforward representation. If Mrs. Cameron's response to her sitters still has something of the painter about it, she is also aware of the ability of the camera,

on one level, to record without comment. Her best photographs combine the non-committal surface accuracy, unique to photography, with an underlying search for the 'Ideal'. She looked at her sitters with determined optimism. Our mood may be different, but her photographs still retain their beauty and poignancy, also the odd touch of wildness and eccentricity, which tended to be ironed out in painted portraits of the period, but which Mrs. Cameron, however great her admiration for the sitter, cannot quite disguise.

MRS. CAMERON'S
PHOTOGRAPHIC METHODS

Mrs. Cameron used the wet collodion process, which had been invented by Frederick Scott-Archer in 1851. A glass plate was used instead of paper as a surface for the emulsion. The glass was free of grain and therefore gave much better definition than the textured paper negative did. Scott-Archer had found that collodion, a solution of gun cotton in alcohol, was a suitable medium for carrying the chemicals, as long as the solution, which supported the chemicals, remained wet. The plates had

therefore to be prepared by the photographer on the site.

A highly polished, spotless glass plate had to be evenly coated with collodion solution and dipped into a bath of nitrate of silver to make the emulsion sensitive to light. It was then taken out, in semi-darkness, fitted into a slide, placed in the camera, exposed, and then immediately developed. A knock, changes in temperature, even breathing on the glass surface might spoil the negative, which was probably twelve inches by fifteen inches, and so extremely tricky to handle. After exposure, the developing solution had to be poured over the plate. If the negative had survived thus far it had to be varnished to protect the chemical surface. This involved heating the plate and once again pouring liquid over it, with the risk that the varnish might crack the collodion surface.

Mrs. Cameron preferred to print her negatives on silver chloride sensitised paper rather than the more popular albumen paper, which was soaked in white of egg before being sensitised, and was claimed to give better definition. She sensitised the papers herself – child's play compared to the preparation of the negative. She was an impetuous and clumsy woman, so it is amazing that she managed to handle the chemical manœuvres as successfully as she did.

For her long exposures Mrs. Cameron used daylight

but to much more dramatic effect than her contemporaries. She disapproved of retouching and was not even prepared to dot out spots on the print. In a letter to Sir Edward Ryan she says, 'Lastly as to spots, they must, I think remain. I could have them touched out, but I am the only photographer who always issues untouched photographs and artists for this reason, amongst others, value my photographs. So Mr. Watts and Mr. Rossetti and Mr. du Maurier write me above all others.'

The characteristic out-of-focus effect is probably the result of using a lens of long focal length, which was necessary to cover the area of the plate. She would have worked with a wide open aperture at a distance of a few feet from her sitter, so there was very little depth of focus and increasing loss of definition in the outer areas of the photograph. While this could enhance the picture, there was little that Mrs. Cameron could do to prevent it, with her equipment and approach. Sitters would have to maintain their pose for three to seven minutes.

The intensity of feeling which Mrs. Cameron put into her photographic sessions made them a tremendous ordeal:

> The studio, I remember, was very untidy and very uncomfortable. Mrs. Cameron put a crown on my head and posed me as the heroic queen.

This was somewhat tedious, but not half so bad as the exposure. Mrs. Cameron warned me before it commenced that it would take a long time, adding, with a sort of half groan, that it was the sole difficulty she had to contend with in working with large plates. The difficulties of development she did not seem to trouble about. The exposure began. A minute went over and I felt as if I must scream, another minute and the sensation was as if my eyes were coming out of my head; a third and the back of my neck appeared to be afflicted with palsy, a fourth, and the crown, which was too large, began to slip down my forehead; a fifth, but here I utterly broke down, for Mr. Cameron, who was very aged, and had unconquerable fits of hilarity which always came in the wrong places, began to laugh audibly, and this was too much for my self-possession, and I was obliged to join the dear old gentleman. When Mrs. Cameron with the assistance of 'Mary' – the beautiful girl who figured in so many pictures, and notably in the picture called the 'Madonna' – bore off the gigantic dark slide with the remark that she was afraid I had moved, I was obliged to tell her that I was sure I had. This first picture was nothing but a series of 'wobblings' and so was the second; the third was more successful, though the torture of standing for nearly ten minutes without a headrest was something indescribable. I have a copy of that picture now.

The face and crown have not more than six out-
lines, and if it was Mrs. Cameron's intention to
represent Zenobia in the last stage of misery and
desperation, I think she succeeded.

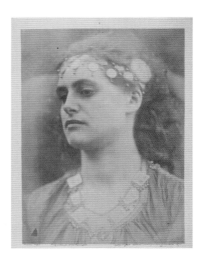

Virginia Woolf

Julia Margaret Cameron

1926

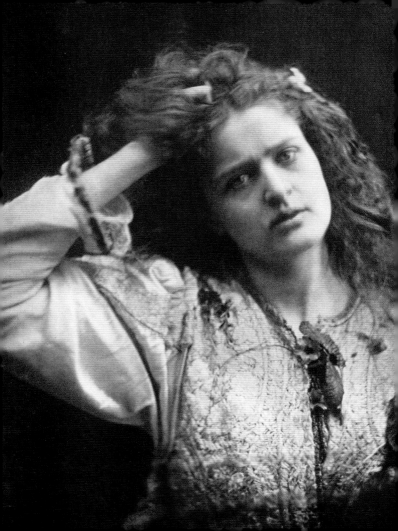

Julia Margaret Cameron, the third daughter of James Pattle of the Bengal Civil Service, was born on June 11, 1815. Her father was a gentleman of marked, but doubtful, reputation, who after living a riotous life and earning the title of 'the biggest liar in India', finally drank himself to death and was consigned to a cask of rum to await shipment to England. The cask was stood outside the widow's bedroom door. In the middle of the night she heard a violent explosion, rushed out, and found her husband, having burst the lid off his coffin, bolt upright menacing her in death as he had menaced her in life. 'The shock sent her off her head then and there, poor thing, and she died raving.' It is the father of Miss Ethel Smyth who tells the story (*Impressions that Remained*), and he goes on to say that, after 'Jim Blazes' had been nailed down again and shipped off, the sailors drank the liquor in which the body was preserved, 'and, by Jove, the rum ran out and got alight and set the ship on fire! And while they were trying to extinguish the flames she ran on a rock, blew up, and drifted ashore just below Hooghly. And what do you think the sailors said? "That Pattle had been such a scamp that the devil wouldn't let him go out of India!"'

Opposite: Ophelia (Emily Peacock), 1874

His daughter inherited a strain of that indomitable vitality. If her father was famous for his lies, Mrs. Cameron had a gift of ardent speech and picturesque behaviour which has impressed itself upon the calm pages of Victorian biography. But it was from her mother, presumably, that she inherited her love of beauty and her distaste for the cold and formal conventions of English society. For the sensitive lady whom the sight of her husband's body had killed was a Frenchwoman by birth. She was the daughter of Chevalier Antoine de l'Étang, one of Marie Antoinette's pages, who had been with the Queen in prison till her death, and was only saved by his own youth from the guillotine. With his wife, who had been one of the Queen's ladies, he was exiled to India, and it is at Ghazipur, with the miniature that Marie Antoinette gave him laid upon his breast, that he lies buried.

But the de l'Étangs brought from France a gift of greater value than the miniature of the unhappy Queen. Old Madame de l'Étang was extremely handsome. Her daughter, Mrs. Pattle, was lovely. Six of Mrs. Pattle's seven daughters were even more lovely than she was. 'Lady Eastnor is one of the handsomest women I ever saw in any country,' wrote Henry Greville of the youngest, Virginia. She underwent

the usual fate of early Victorian beauty: was mobbed in the streets, celebrated in odes, and even made the subject of a paper in *Punch* by Thackeray, 'On a good-looking young lady'. It did not matter that the sisters had been brought up by their French grandmother in household lore rather than in book learning. 'They were artistic to their finger tips, with an appreciation – almost to be called a *culte* – for beauty.' In India their conquests were many, and when they married and settled in England, they had the art of making round them, whether at Freshwater or at Little Holland House, a society of their own ('Pattledom' it was christened by Sir Henry Taylor), where they could drape and arrange, pull down and build up, and carry on life in a high-handed and adventurous way which painters and writers and even serious men of affairs found much to their liking. 'Little Holland House, where Mr. Watts lived, seemed to me a paradise,' wrote Ellen Terry, 'where only beautiful things were allowed to come. All the women were graceful, and all the men were gifted.' There, in the many rooms of the old Dower House, Mrs. Prinsep lodged Watts and Burne-Jones, and entertained innumerable friends among lawns and trees which seemed deep in the country, though the traffic of Hyde Park Corner was only two miles distant. Whatever they

did, whether in the cause of religion or of friendship, was done enthusiastically.

Was a room too dark for a friend? Mrs. Cameron would have a window built instantly to catch the sun. Was the surplice of the Rev. C. Beanlands only passably clean? Mrs. Prinsep would set up a laundry in her own house and wash the entire linen of the clergy of St. Michael's at her own expense. Then when relations interfered, and begged her to control her extravagance, she nodded her head with its coquettish white curls obediently, heaved a sigh of relief as her counsellors left her, and flew to the writing-table to despatch telegram after telegram to her sisters describing the visit. 'Certainly no one could restrain the Pattles but themselves,' says Lady Troubridge. Once indeed the gentle Mr. Watts was known to lose his temper. He found two little girls, the granddaughters of Mrs. Prinsep, shouting at each other with their ears stopped so that they could hear no voices but their own. Then he delivered a lecture upon self-will, the vice, he said, which they had inherited from their French ancestress, Madame de l'Étang. 'You will grow up imperious women,' he told them, 'if you are not careful.' Had they not into the bargain an ancestor who blew the lid off his coffin?

Certainly Julia Margaret Cameron had grown up

an imperious woman; but she was without her sisters'
beauty. In the trio where, as they said, Lady Somers
was Beauty, and Mrs. Prinsep Dash, Mrs. Cameron
was undoubtedly Talent.

'She seemed in herself to epitomize all the quali-
ties of a remarkable family,' wrote Mrs. Watts, 'pre-
senting them in a doubly distilled form. She doubled
the generosity of the most generous of the sisters,
and the impulsiveness of the most impulsive. If they
were enthusiastic, she was so twice over; if they were
persuasive, she was invincible. She had remarkably
fine eyes, that flashed like her sayings, and grew soft
and tender if she was moved…' But to a child[1] she
was a terrifying apparition, 'short and squat, with
none of the Pattle grace and beauty about her,
though more than her share of their passionate ener-
gy and wilfulness. Dressed in dark clothes, stained
with chemicals from her photography (and smelling
of them too), with a plump eager face and a voice
husky, and a little harsh, yet in some way compelling
and even charming', she dashed out of the studio at
Dimbola, attached heavy swans' wings to the chil-
dren's shoulders, and bade them 'Stand there' and
play the part of the Angels of the Nativity leaning
over the ramparts of Heaven.

1. *Memories and Reflections* by Lady Troubridge, p. 34.

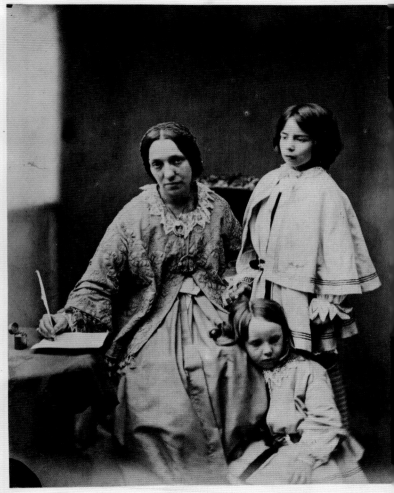

Mrs Cameron · Charles & Henry
sons.

But the photography and the swans' wings were still in the far future. For many years her energy and her creative powers poured themselves into family life and social duties. She had married, in 1838, a very distinguished man, Charles Hay Cameron, 'a Benthamite jurist and philosopher of great learning and ability', who held the place, previously filled by Lord Macaulay, of fourth Member of Council at Calcutta. In the absence of the Governor-General's wife, Mrs. Cameron was at the head of European society in India, and it was this, in Sir Henry Taylor's opinion, that encouraged her in her contempt for the ways of the world when they returned to England. She had little respect, at any rate, for the conventions of Putney. She called her butler peremptorily 'Man'. Dressed in robes of flowing red velvet, she walked with her friends, stirring a cup of tea as she walked, half-way to the railway station in hot summer weather. There was no eccentricity that she would not have dared on their behalf, no sacrifice that she would not have made to procure a few more minutes of their society. Sir Henry and Lady Taylor suffered the extreme fury of her affection. Indian shawls, turquoise bracelets, inlaid portfolios, ivory elephants,

Opposite: Julia Margaret Cameron and her sons, 1857-8, by an unknown photographer. The family was then living in Putney

'etc.', showered on their heads. She lavished upon them letters six sheets long 'all about ourselves'. Rebuffed for a moment, 'she told Alice [Lady Taylor] that before the year was out she would love her like a sister', and before the year was out Lady Taylor could hardly imagine what life had been without Mrs. Cameron. The Taylors loved her; Aubrey de Vere loved her; Lady Monteagle loved her; and 'even Lord Monteagle, who likes eccentricity in no other form, likes her'. It was impossible, they found, not to love that 'genial, ardent, and generous' woman, who had 'a power of loving which I have never seen exceeded, and an equal determination to be loved'. If it was impossible to reject her affection, it was even danger-ous to reject her shawls. Either she would burn them, she threatened, then and there, or, if the gift were returned, she would sell it, buy with the proceeds a very expensive invalid sofa, and present it to the Putney Hospital for Incurables with an inscription which said, much to the surprise of Lady Taylor, when she chanced upon it, that it was the gift of Lady Taylor herself. It was better, on the whole, to bow the shoulder and submit to the shawl.

Meanwhile she was seeking some more permanent expression of her abundant energies in literature. She translated from the German, wrote poetry, and

finished enough of a novel to make Sir Henry Taylor very nervous lest he should be called upon to read the whole of it. Volume after volume was despatched through the penny post. She wrote letters till the postman left, and then she began her postscripts. She sent the gardener after the postman, the gardener's boy after the gardener, the donkey galloping all the way to Yarmouth after the gardener's boy. Sitting at Wandsworth Station she wrote page after page to Alfred Tennyson until 'as I was folding your letter came the screams of the train, and then the yells of the porters with the threat that the train would not wait for me', so that she had to thrust the document into strange hands and run down the steps. Every day she wrote to Henry Taylor, and every day he answered her.

Very little remains of this enormous daily volubility. The Victorian age killed the art of letter writing by kindness: it was only too easy to catch the post. A lady sitting down at her desk a hundred years before had not only certain ideals of logic and restraint before her, but the knowledge that a letter which cost so much money to send and excited so much interest to receive was worth time and trouble. With Ruskin and Carlyle in power, a penny post to stimulate, a gardener, a gardener's boy, and a galloping donkey to catch

up the overflow of inspiration, restraint was unnecessary and emotion more to a lady's credit, perhaps, than common sense. Thus to dip into the private letters of the Victorian age is to be immersed in the joys and sorrows of enormous families, to share their whooping coughs and colds and misadventures, day by day, indeed hour by hour. The standard of family affection was very high. Illness elicited showers of enquiries and kindnesses. The weather was watched anxiously to see whether Richard would be wet at Cheltenham, or Jane catch cold at Broadstairs. Grave misdemeanours on the part of governesses, cooks, and doctors ('he is guilty of culpable carelessness, profound ignorance,' Mrs. Cameron would say of the family physician), were detailed profusely, and the least departure from family morality was vigilantly pounced upon and volubly imparted.

Mrs. Cameron's letters were formed upon this model; she counselled and exhorted and enquired after the health of dearest Emily with the best; but her correspondents were often men of exalted genius to whom she could express the more romantic side of her nature. To Tennyson she dwelt upon the beauty of Mrs. Hambro, 'frolicsome and graceful as a kitten and having the form and eye of an antelope ... Then her complexion (or rather her skin) is faultless – it is

like the leaf of 'that consummate flower' the Magnolia – a flower which is, I think, so mysterious in its beauty as if it were the only thing left unsoiled and unspoiled from the garden of Eden … We had a standard Magnolia tree in our garden at Sheen, and on a still summer night the moon would beam down upon those ripe rich vases, and they used to send forth a scent which made the soul faint with a sense of the luxury of the world of flowers'. From such sentences it is easy to see why Sir Henry Taylor looked forward to reading her novel with dread. 'Her genius (of which she has a great deal) is too profuse and redundant, not distinguishing between felicitous and infelicitous,' he wrote. 'She lives upon superlatives as upon her daily bread.'

But the zenith of Mrs. Cameron's career was at hand. In 1860 the Camerons bought two or three rose-covered cottages at Freshwater, ran them together, and supplemented them with outhouses to receive the overflow of their hospitality. For at Dimbola – the name was taken from Mr. Cameron's estate in Ceylon – everybody was welcome. 'Conventionalities had no place in it.' Mrs. Cameron would invite a family met on the steamer to lunch without asking their names, would ask a hatless tourist met on the cliff to come in and choose himself a hat, would adopt an Irish

beggar woman and send her child to school with her own children. 'What will become of her?' Henry Taylor asked, but comforted himself with the reflection that though Julia Cameron and her sisters 'have more of hope than of reason', still 'the humanities are stronger in them than the sentimentalities', and they generally brought their eccentric undertakings to a successful end. In fact the Irish beggar child grew up into a beautiful woman, became Mrs. Cameron's parlour-maid, sat for her portrait, was sought in marriage by a rich man's son, filled the position with dignity and competence, and in 1878 enjoyed an income of two thousand four hundred pounds a year. Gradually the cottages took colour and shape under Mrs. Cameron's hands. A little theatre was built where the young people acted. On fine nights they traipsed up to the Tennysons and danced; if it were stormy, and Mrs. Cameron preferred the storm to the calm, she paced the beach and sent for Tennyson to come and pace by her side. The colour of the clothes she wore, the glitter and hospitality of the household she ruled, reminded visitors of the East. But if there was an element of 'feudal familiarity', there was also a sense of 'feudal discipline'. Mrs. Cameron was extremely

Opposite: Mary Ryan and her fiancé, Henry John Stedman Cotton, as Romeo and Juliet, July 1867

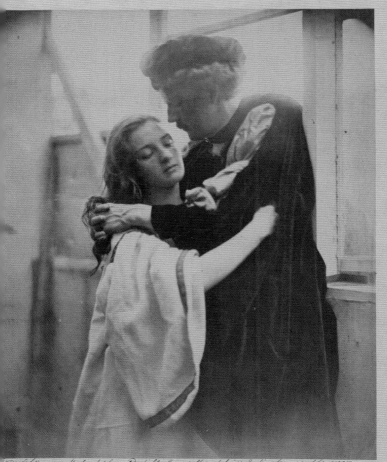

Yet I should kill thee with much cherishing Julia Margaret Cameron
Good night, good night, parting is such sweet sorrow
That I could say good night until tomorrow Romeo and Juliet

outspoken. She could be highly despotic. 'If ever you fall into temptation,' she said to a cousin, 'down on your knees and think of Aunt Julia.' She was caustic and candid of tongue. She chased Tennyson into his tower vociferating 'Coward! Coward!' and thus forced him to be vaccinated. She had her hates as well as her loves, and alternated in spirits 'between the seventh heaven and the bottomless pit'. There were visitors who found her company agitating, so odd and bold were her methods of conversation, while the variety and brilliance of the society she collected round her caused a certain 'poor Miss Stephen' to lament: 'Is there *nobody* commonplace?' as she saw Jowett's four young men drinking brandy and water, heard Tennyson reciting 'Maud', while Mr. Cameron wearing a coned hat, a veil, and several coats paced the lawn which his wife in a fit of enthusiasm had created during the night.

In 1865, when she was fifty, her son's gift of a camera gave her at last an outlet for the energies which she had dissipated in poetry and fiction and doing up houses and concocting curries and entertaining her friends. Now she became a photographer. All her sensibility was expressed, and, what was perhaps more to the purpose, controlled in the new born art. The coal-house was turned into a dark room; the fowl-house

was turned into a glass-house. Boatmen were turned into King Arthur; village girls into Queen Guenevere. Tennyson was wrapped in rugs: Sir Henry Taylor was crowned with tinsel. The parlour-maid sat for her portrait and the guest had to answer the bell. 'I worked fruitlessly but not hopelessly,' Mrs. Cameron wrote of this time. Indeed, she was indefatigable. 'She used to say that in her photography a hundred negatives were destroyed before she achieved one good result; her object being to overcome realism by diminishing just in the least degree the precision of the focus.' Like a tigress where her children were concerned, she was as magnificently uncompromising about her art. Brown stains appeared on her hands, and the smell of chemicals mixed with the scent of the sweet briar in the road outside her house. She cared nothing for the miseries of her sitters nor for their rank. The carpenter and the Crown Prince of Prussia alike must sit as still as stones in the attitudes she chose, in the draperies she arranged, for as long as she wished. She cared nothing for her own labours and failures and exhaustion. 'I longed to arrest all the beauty that came before me, and at length the longing was satisfied,' she wrote. Painters praised her art; writers marvelled at the character her portraits revealed. She herself blazed up at length into

satisfaction with her own creations. 'It is a sacred blessing which has attended my photography,' she wrote. 'It gives pleasure to millions.' She lavished her photographs upon her friends and relations, hung them in railway waiting-rooms, and offered them, it is said, to porters in default of small change.

Old Mr. Cameron meanwhile retired more and more frequently to the comparative privacy of his bedroom. He had no taste for society himself, but endured it, as he endured all his wife's vagaries, with philosophy and affection. 'Julia is slicing up Ceylon,' he would say, when she embarked on another adventure or extravagance. Her hospitalities and the failure of the coffee crop ('Charles speaks to me of the flower of the coffee plant. I tell him that the eyes of the first grandchild should be more beautiful than any flowers,' she said) had brought his affairs into a precarious state. But it was not business anxieties alone that made Mr. Cameron wish to visit Ceylon. The old philosopher became more and more obsessed with the desire to return to the East. There was peace; there was warmth; there were the monkeys and the elephants whom he had once lived among 'as a friend and a brother'. Suddenly, for the secret had been kept from their friends, the Camerons announced that

Opposite: Charles Hay Cameron in his garden at Freshwater, 1865-1867.

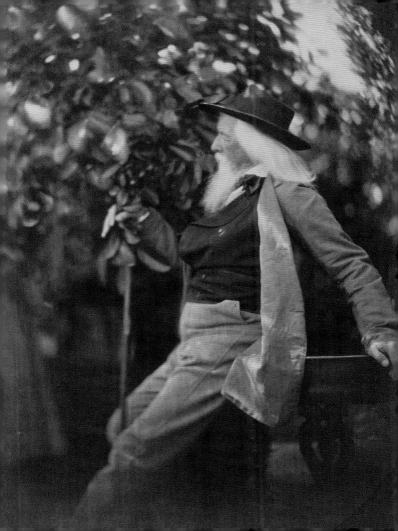

they were going to visit their sons in Ceylon. Their preparations were made and friends went to say good-bye to them at Southampton. Two coffins preceded them on board packed with glass and china, in case coffins should be unprocurable in the East; the old philosopher with his bright fixed eyes and his beard 'dipt in moonlight' held in one hand his ivory staff and in the other Lady Tennyson's parting gift of a pink rose; while Mrs. Cameron, 'grave and valiant', vociferated her final injunctions and controlled not only innumerable packages but a cow. They reached Ceylon safely, and in her gratitude Mrs. Cameron raised a subscription to present the Captain with a harmonium. Their house at Kalutara was so surrounded by trees that rabbits and squirrels and minah birds passed in and out while a beautiful tame stag kept guard at the open door. Marianne North, the traveller, visited them there and found old Mr. Cameron in a state of perfect happiness, reciting poetry, walking up and down the verandah, with his long white hair flowing over his shoulders, and his ivory staff held in his hand. Within doors Mrs. Cameron still photographed. The walls were covered with magnificent pictures which tumbled over the tables and chairs and mixed in picturesque confusion with books and draperies. Mrs. Cameron at once

made up her mind that she would photograph her visitor and for three days was in a fever of excitement. 'She made me stand with spiky coconut branches running into my head … and told me to look perfectly natural,' Miss North remarked. The same methods and ideals ruled in Ceylon that had once ruled in Freshwater. A gardener was kept, though there was no garden and the man had never heard of the existence of such a thing, for the excellent reason that Mrs. Cameron thought his back 'absolutely superb'. And when Miss North incautiously admired a wonderful grass green shawl that Mrs. Cameron was wearing, she seized a pair of scissors, and saying: 'Yes, that would just suit you', cut it in half from corner to corner and made her share it. At length, it was time for Miss North to go. But still Mrs. Cameron could not bear that her friends should leave her. As at Putney she had gone with them stirring her tea as she walked, so now at Kalutara she and her whole household must escort her guest down the hill to wait for the coach at midnight. Two years later (in 1879) she died. The birds were fluttering in and out of the open door; the photographs were tumbling over the tables; and, lying before a large open window, Mrs. Cameron saw the stars shining, breathed the one word 'Beautiful', and so died.

EDITOR'S NOTE

Some corrections are needed to Virginia Woolf's dramatic account of the departure of Mrs. Cameron's father from India, which was based on Ethel Smyth's *Impressions that Remained*. These impressions were not always strictly accurate. There is no reliable evidence to suggest that James Pattle, who held responsible posts on the financial and judicial side of the Bengal Civil Service, drank more than his contemporaries. Ethel Smyth was probably confusing him with his brother Colonel Pattle, who had the reputation of being wild and untruthful. James Pattle's body was brought back to England and is buried at St. Giles' Church, Camberwell. His wife did not die insane. She had very bad health for some years and died on board ship on the voyage to England.

The Chevalier de l'Étang was banished by the King *before* the Revolution, when he was an officer of the King's bodyguard and superintendent of the Royal Stud – he had written a book on horse management for the French army.

Mme. de l'Étang was not 'one of the Queen's ladies'.

She was born in Pondicherry, India, the daughter of the Captain of the Port, and she did not go to France until she took her grand-daughter there to be educated, probably in the 1820s.

It is worth looking at the ramifications of the Pattle family, because many of them figure in Mrs. Cameron's photographs. The seven surviving daughters of James and Adeline Pattle were: Adeline (1812-1836) who married Colin MacKenzie (later General); Julia Margaret (1815-1879) who married Charles Hay Cameron, a jurist responsible for the codification of the Indian legal system; Sarah (1816-1887) who married Henry Thoby Prinsep, an official in the East India Company; Maria (1818-1892) who married Dr. John Jackson; Louisa (1821-1873) who married H. V. Bayley; Virginia (1827-1910) who married Lord Eastnor (later Earl Somers); Sophia (1829-1911) who married Sir John Dalrymple.

Sarah Prinsep's daughter Alice married Charles Gurney and had two daughters, Laura and Rachel. Laura (Queenie) married Sir Thomas Troubridge and Rachel the Earl of Dudley. Laura Troubridge had a son, Ernest, who married Una Taylor, who later married John Radcliffe Hall and wrote *The Well of Loneliness*.

Maria Jackson had three daughters, Adeline, who married Henry Halford Vaughan, Mary who married Herbert Fisher, and Julia, who married first Herbert Duckworth and second Leslie Stephen. Herbert Fisher was tutor to the Prince of Wales (later Edward VII) and father of H. A. L. Fisher the historian, and Florence, the wife of F. W. Maitland. The two daughters of Julia's marriage to Sir Leslie Stephen, the philosopher and creator of the *Dictionary of National Biography*, were Vanessa, later the wife of Clive Bell, and Virginia, who became the wife of Leonard Woolf; the two sons were Thoby and Adrian Stephen.

The Tennyson family were close friends with the Camerons, and May Prinsep, Sarah and Henry Thoby Prinsep's niece, married Hallam, Lord Tennyson, as his second wife. Besides her famous studies of the poet, Mrs. Cameron also photographed his brother Horatio and his sons, Hallam and Lionel.

Of Mrs. Cameron's children, only her daughter Julia, who married Charles Lloyd Norman, D.L., J.P., and her eldest son Eugene, who married Caroline Browne, left any descendants beyond the first generation. In fact only one other of her five sons, Ewen, married. He left a son and a daughter, both of whom died childless.

Julia Margaret Cameron

The Annals of My Glass House

1874

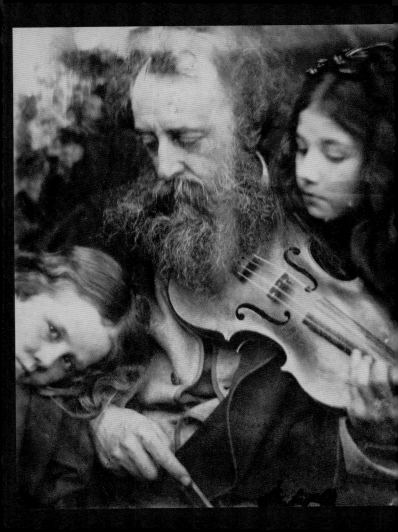

*M*rs. Cameron's photography, now ten years old, has passed the age of lisping and stammering and may speak for itself, having travelled over Europe, America, and Australia, and met with a welcome which has given it confidence and power. Therefore, I think that the 'Annals of My Glass House' will be welcome to the public, and endeavouring to clothe my little history with light, as with a garment, I feel confident that the truthful account of indefatigable work, with the anecdotes of human interest attached to that work, will add in some measure to its value.

That details strictly personal and touching the affections should be avoided is a truth one's own instinct would suggest, and noble are the teachings of one whose word has become a text to the nations –

> Be wise: not easily forgotten
> Are those, who setting wide the doors that bar
> The secret bridal chamber of the heart
> Let in the day.*

Therefore it is with effort that I restrain the overflow

* Tennyson: 'The Gardener's Daughter'

Opposite: The Whisper of the Muse, 1865 (G. F. Watts, Lizzie and Katie Keown)

of my heart and simply state that my first lens was given to me by my cherished daughter and her husband with the words, 'It may amuse you, Mother, to try to photograph during your solitude at Freshwater.'

The gift from those I loved so tenderly added more and more impulse to my deeply seated love of the beautiful, and from the first moment I handled my lens with a tender ardour, and it has become to me as a living thing, with voice and memory and creative vigour. Many and many a week in the year '64 I worked fruitlessly, but not hopelessly –

A crown of hopes
That sought to sow themselves like winged lies
Born out of everything I heard and saw
Fluttered about my senses and my soul.

I longed to arrest all beauty that came before me, and at length the longing has been satisfied. Its difficulty enhanced the value of the pursuit. I began with no knowledge of the art. I did not know where to place my dark box, how to focus my sitter, and my first picture I effaced to my consternation by rubbing my hand over the filmy side of the glass.

It was a portrait of a farmer of Freshwater, who, to my fancy, resembled Bolingbroke. The peasantry of

our island is very handsome. From the men, the women, the maidens and the children I have had lovely subjects, as all the patrons of my photography know.

This farmer I paid a half-crown an hour, and, after many half-crowns and many hours spent in experiments, I got my first picture, and this was the one I effaced when holding it triumphantly to dry.

I turned my coal-house into my dark room, and a glazed fowl-house I had given to my children became my glass house! The hens were liberated, I hope and believe not eaten. The profit of my boys upon new laid eggs was stopped, and all hands and hearts sympathized in my new labour, since the society of hens and chickens was soon changed for that of poets, prophets, painters and lovely maidens, who all in turn have immortalized the humble little farm erection.

Having succeeded with one farmer, I next tried two children; my son Hardinge, being on his Oxford vacation, helped me in the difficulty of focusing. I was halfway through a beautiful picture when a splutter of laughter from one of the children lost me that picture, and less ambitious now, I took one child alone, appealing to her feelings and telling her of the waste of poor Mrs. Cameron's chemicals and strength if she moved. The appeal had its effect, and I now produced a picture which I called 'My First Success'.

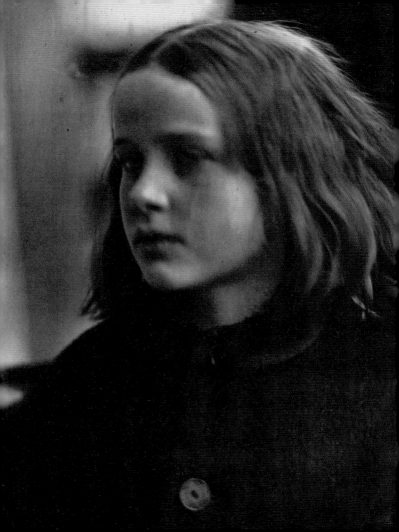

I was in a transport of delight. I ran all over the house to search for gifts for the child. I felt as if she entirely had made the picture. I printed, toned, fixed and framed it, and presented it to her father that same day: size, 11 by 9 inches.

Sweet, sunny haired little Annie! No later prize has effaced the memory of this joy, and now that this same Annie is 19, how much I long to meet her and try my master hand upon her.

Having thus made my start, I will not detain my readers with other details of small interest; I only had to work on and to reap rich reward.

I believe that what my youngest boy, Henry Herschel, who is now himself a very remarkable photographer, told me is quite true – that my first successes in my out-of-focus pictures were a fluke. That is to say, that when focusing and coming to something which, to my eye, was very beautiful, I stopped there instead of screwing on the lens to the more definite focus which all other photographers insist upon.

I exhibited as early as May '65. I sent some photographs to Scotland – a head of Henry Taylor, with the light illuminating the countenance in a way that cannot be described; a Raphaelesque Madonna,

Opposite: 'My First Success', January 29, 1864 (Annie Philpot)

called 'La Madonna Aspettante'. These photographs still exist, and I think they cannot be surpassed. They did not receive the prize. The picture that did receive the prize, called 'Brenda', clearly proved to me that the detail of table-cover, chair and crinoline skirt were essential to the judges of the art, which was then in its infancy. Since that miserable specimen, the author of 'Brenda' has so greatly improved that I am content to compete with him and content that those who value fidelity and manipulation should find me still behind him. Artists, however, immediately crowned me with laurels, and though 'Fame' is pronounced 'The last infirmity of noble minds', I must confess that when those whose judgment I revered have valued and praised my works, 'my heart has leapt up like a rainbow in the sky', and I have renewed all my zeal.

The Photographic Society of London in their *Journal* would have dispirited me very much had I not valued that criticism at its worth. It was unsparing and too manifestly unjust for me to attend to it. The more lenient and discerning judges gave me a large space upon their walls which seemed to invite the irony and spleen of the printed notice.

Opposite: La Madonna Aspettante, 'Yet a Little While', March 1865
(Mary Hillier and Freddy Gould)

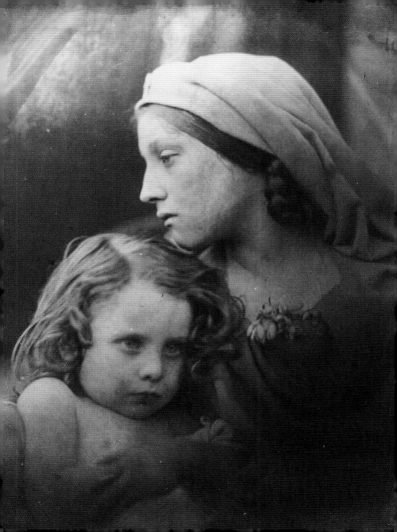

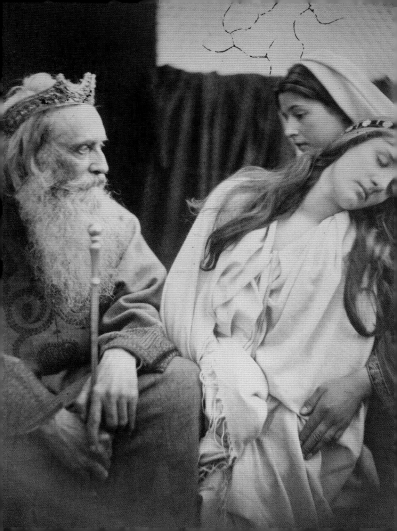

To Germany I next sent my photographs. Berlin, the very home of photographic art, gave me the first year a bronze medal, the succeeding year a gold medal, and one English institution – the Hartly Institution – awarded me a silver medal, taking, I hope, a home interest in the success of one whose home was so near to Southampton.

Personal sympathy has helped me on very much. My husband from first to last has watched every picture with delight, and it is my daily habit to run to him with every glass upon which a fresh glory is newly stamped, and to listen to his enthusiastic applause. This habit of running into the dining-room with my wet picture has stained such an immense quantity of table linen with nitrate of silver, indelible stains, that I should have been banished from any less indulgent household.

Our chief friend, Sir Henry Taylor, lent himself greatly to my early efforts. Regardless of the possible dread that sitting to my fancy might be making a fool of himself, he, with greatness which belongs to unselfish affection, consented to be in turn Friar Laurence with Juliet, Prospero with Miranda, Ahasuerus with Queen Esther, to hold my poker as

*Opposite: King Ahasuerus and Queen Esther in Apocrypha, 1865
(Sir Henry Taylor, Mary Ryan, Mary Kellaway)*

his sceptre, and do whatever I desired of him. With this great good friend was it true that so utterly

> The chord of self with trembling
> Passed like music out of sight,

and not only were my pictures secured for me, but entirely out of the Prospero and Miranda picture sprung a marriage which has, I hope, cemented the welfare and well-being of a real King Cophetua who, in the Miranda, saw the prize which has proved a jewel in that monarch's crown. The sight of the picture caused the resolve to be uttered which, after 18 months of constancy, was matured by personal knowledge, then fulfilled, producing one of the prettiest idylls of real life that can be conceived, and, what is of far more importance, a marriage of bliss with children worthy of being photographed, as their mother had been, for their beauty; but it must also be observed that the father was eminently handsome, with a head of the Greek type and fair ruddy Saxon complexion.

Another little maid of my own from early girlhood has been one of the most beautiful and constant of my models, and in every manner of form has her

Opposite: Prospero and Miranda, 1865 (Sir Henry Taylor, Mary Ryan)

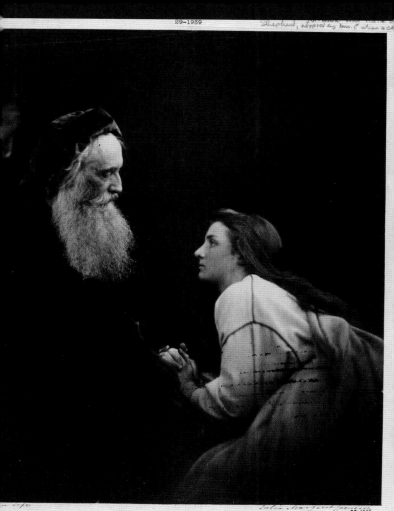

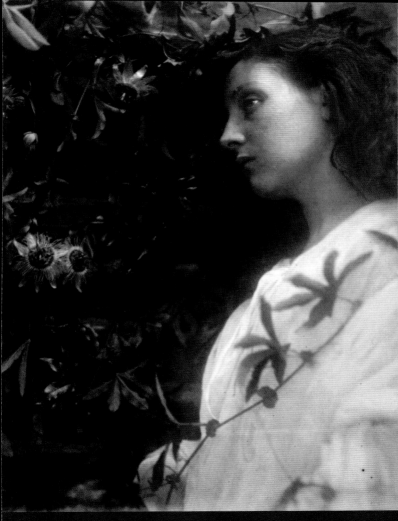

face been reproduced, yet never has it been felt that
the grace of the fashion of it has perished. This last
autumn her head illustrating the exquisite Maud –

> There has fallen a splendid tear
> From the passion flower at the gate,

is as pure and perfect in outline as were my Madonna
Studies ten years ago, with ten times added pathos in
the expression. The very unusual attributes of her
character and complexion of her mind, if I may so
call it, deserve mention in due time, and are the won-
der of those whose life is blended with ours as inti-
mate friends of the house.

I have been cheered by some very precious letters
on my photography, and having the permission of
the writers, I will reproduce some of those which will
have an interest for all.

An exceedingly kind man from Berlin displayed
great zeal, for which I have ever felt grateful to him.
Writing in a foreign language, he evidently consulted
the dictionary which gives two or three meanings for
each word, and in the choice between these two or
three the result is very comical. I only wish that I was
able to deal with all foreign tongues as felicitously:

Opposite: Maud, 1875 (Mary Hillier)

Mr. ------- announces to Mrs. Cameron that he received the first half, a Pound Note, and took the Photographies as Mrs. Cameron wishes. He will take the utmost sorrow* to place the pictures were good.

Mr. -------- and the Comitie regret heavily† that it is now impossible to take the Portfolio the rooms are filled till the least winkle.‡

The English Ambassude takes the greatest interest of the placement the Photographies of Mrs. Cameron and M ------- sent his extra ordinarest respects to the celebrated and famous female photographs. --- Yours most obedient, etc.

The kindness and delicacy of this letter is self-evident and the mistakes are easily explained:

*Care – which was the word needed – is expressed by 'Sorgen' as well as 'Sorrow.' We invert the sentence and we read – To have the pictures well placed where the light is good.

† Regret – Heavily, severely, seriously.

‡ Winkle – is corner in German.

The exceeding civility with which the letter closes is the courtesy of a German to a lady artist, and from

the first to last, Germany has done me honour and kindness until, to crown all my happy associations with that country, it has just fallen to my lot to have the privilege of photographing the Crown Prince and Crown Princess of Germany and Prussia.

This German letter had a refinement which permits one to smile *with* the writer, not *at* the writer. Less sympathetic, however, is the laughter which some English letters elicit, of which I give one example:

> Miss Lydia Louisa Summerhouse Donkins informs Mrs. Cameron that she wishes to sit to her for her photograph. Miss Lydia Louisa Summerhouse Donkins is a carriage person, and, therefore, could assure Mrs. Cameron that she would arrive with her dress uncrumpled.
>
> Should Miss Lydia Louisa Summerhouse Donkins be satisfied with her picture, Miss Lydia Louisa Summerhouse Donkins has a friend who is *also* a Carriage person who would *also* wish to have her likeness taken.

I answered Miss Lydia Louisa Summerhouse Donkins that Mrs. Cameron, not being a professional photographer, regretted she was not able to 'take her likeness', but that had Mrs. Cameron been able

to do so she would have very much preferred having her dress crumpled.

A little art teaching seemed a kindness, but I have more than once regretted that I could not produce the likeness of this individual with her letter affixed thereto.

This was when I was at L. H. H.,[1] to which place I had moved my camera for the sake of taking the great Carlyle.

When I have had such men before my camera my whole soul has endeavoured to do its duty towards them in recording faithfully the greatness of the inner as well as the features of the outer man.

The photograph thus taken has been almost the embodiment of a prayer. Most devoutly was this feeling present to men when I photographed my illustrious and revered as well as beloved friend, Sir John Herschel. He was to me as a Teacher and High Priest. From my earliest girlhood I had loved and honoured him, and it was after a friendship of 31 years' duration that the high task of giving his portrait to the nation was allotted to me. He had corresponded with

1. Little Holland House, the London residence of Mrs. Cameron's sister, Sarah Prinsep.

Opposite: Carlyle, like a rough block of Michelangelo's sculpture, 1867

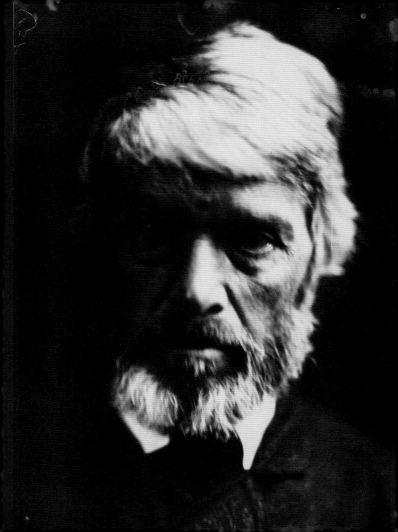

me when the art was in its first infancy in the days of
Talbot-type and Daguerrotype. I was then residing in
Calcutta, and scientific discoveries sent to that then
benighted land were water to the parched lips of the
starved, to say nothing of the blessing of friendship
so faithfully evinced.

When I returned to England the friendship was
naturally renewed. I had already been made god-
mother to one of his daughters, and he consented to
become godfather to my youngest son. A memorable
day it was when my infant's three sponsors stood
before the font, not acting by proxy, but all moved by
real affection to me and to my husband to come in
person, and surely Poetry, Philosophy and Beauty
were never more fitly represented than when Sir
John Herschel, Henry Taylor and my own sister,
Virginia Somers, were encircled round the little font
of the Mortlake Church.

When I began to photograph I sent my first tri-
umphs to my revered friend, and his hurrahs for my
success I here give. The date is September 25th, 1866 –

> My dear Mrs. Cameron, ---
> This last batch of your photographs is indeed
> wonderful, and wonderful in two distinct lines of
> perfection. That head of the 'Mountain Nymph,

Sweet Liberty'[1] (a little *farouche* and *egarée*, by the way, as if first let loose and half afraid that it was too good), is really a most *astonishing* piece of high relief. She is absolutely alive and thrusting out her head from the paper into the air. This is your own Special Style. The other of 'Summer Days'[2] is in the other manner – quite different, but very beautiful, and the grouping perfect. Proserpine is awful. If ever she was 'herself the fairest flower' her 'cropping' by 'Gloomy Dis' has thrown the deep shadows of Hades into not only the colour, but the whole cast and expression of her features. Christabel is a little too indistinct for my mind, but a fine head.[3] The large profile is admirable, and altogether you seem resolved to out-do your-self on every fresh effort.

This was encouragement eno' for me to feel myself held worthy to take this noble head of my great Master myself, but three years I had to wait patiently and longingly before the opportunity could offer.[4]

Meanwhile I took another immortal head, that of Alfred Tennyson, and the result was that profile portrait which he himself designates as the 'Dirty

1. See Plate 27. 2. Plate 29. 3. Plate 37. 4. Plates 1 & 2.

Monk.'[1] It is a fit representation of Isaiah or of Jeremiah, and Henry Taylor said the picture was as fine as Alfred Tennyson's finest poem. The Laureate has since said of it that he likes it better than any photograph that has been taken of him *except* one by Mayall; that '*except*' speaks for itself. The comparison seems too comical. It is rather like comparing one of Madame Tussaud's waxwork heads to one of Woolner's ideal heroic busts. At this same time Mr. Watts gave me such encouragement that I felt as if I had wings to fly with.

1. Plate 4.

Julia Margaret Cameron

On a Portrait

September 1875

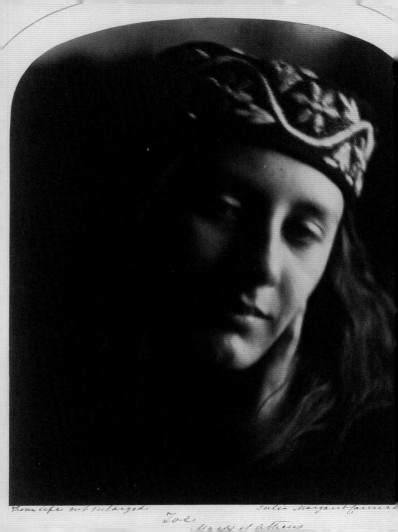

Oh, mystery of Beauty! Who can tell
 Thy might influence? Who can best descry
How secret, swift, and subtle is the spell
 Wherein the music of thy voice doth lie?

Here we have eyes so full of fervent love,
 That but for lids behind which sorrow's touch
Doth press and linger, one could almost prove
 That Earth had loved her favourite over much.

A mouth where silence seems to gather strength
 From lips so gently closed, that almost say,
"Ask not my story, lest you hear at length
 Of sorrows where sweet hope has lost its way."

And yet the head is borne so proudly high,
 The soft round cheek, so splendid in its bloom,
True courage rises thro' the brilliant eye,
 And great resolve comes flashing thro' the gloom.

Opposite: Zoe, Maid of Athens (May Prinsep), 1866. Zoe was a heroine of the Greek War of Independence. This print belonged to G. F. Watts.

Oh, noble painter! More than genius goes
 To search the key-note of those melodies,
To find the depths of all those tragic woes,
 Tune thy song right and paint rare harmonies.

Genius and love have each fulfilled their part,
 And both unite with force and equal grace,
Whilst all that we love best in classic art
 Is stamped for ever on the immortal face.

Roger Fry

Mrs. Cameron's Photographs

1926

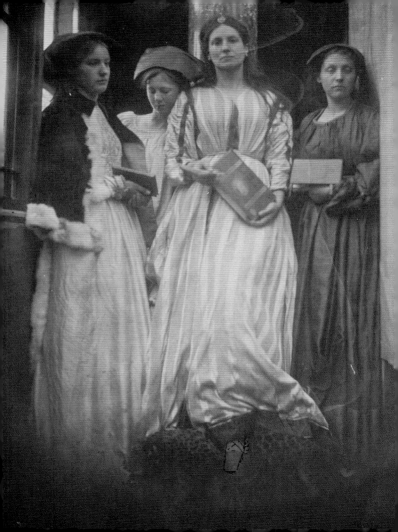

The position of photography is uncertain and uncomfortable. No one denies its immense services of all kinds, but its status as an independent art has always been disputed. It has never managed to get its Muse or any proper representation on Parnassus, and yet it will not give up its pretentions altogether. Mrs. Cameron's photographs posed the question long ago, but it was shelved. The present publication affords perhaps a favourable opportunity to reopen the discussion.

But before we consider the abstract æsthetic problem, it will be as well to look at some of her plates and find out what it is that she has handed on to posterity. To begin with, surely the most fascinating record of a period. I doubt if any period in all history has been transmitted as this of England of the 60's and 70's of last century is through Mrs. Cameron's plates. A number of things contribute to decide whether a period can be transmitted or not. Much depends on the current attitude at any given moment of men to their own personality. In the Renaissance men were much too proud of being whatever odd

Opposite: The Princess, 1875 (Miss Johnson, Miss Johnson, unknown woman, Mary Hillier). 'She stood/Among her maidens, higher by the head,/Her back against a pillar.' (Tennyson, The Princess)

73

thing heredity, fate, and circumstance had happened to make them, to wish from the portraitist but the most literal and complete truth he could give. At other periods, the seventeenth century, for instance, men were, for some reason or other, more anxious to insist on the fact that they conformed to the type of the day. They insisted that the artist should, so far as possible, squeeze them into conformity with that. The same is true of the present moment, when, though the fashionable portraits, photographed or otherwise, are as like as peas to one another, they are not like any individual human being at all.

Now it so happens that in the 60's and 70's England was enjoying a spell of strong individualism. People were indeed excessively careful to conform to a certain code of morals, but within the limits of that they were not afraid of their own personalities.

That, then, was a favouring condition, and it coincided with the spread of photography and the appearance of Mrs. Cameron.

And in this matter of the transmission of a period, photography is of immense importance. Not but what van Eyck and Ghirlandaio were able to transmit much to us, only whenever an artist attains to the power of realizing the human face with anything like the same completeness as the photograph does he is almost

certain to be so great an artist as to stand between us and his sitters. Rembrandt, for instance, is so infinitely more important to us than any of his sitters, himself included, that we pass at once into the universal and dateless world which his imagination created for us. We get much nearer to seventeenth-century Holland in Terborgh or Metsu than in Rembrandt.

So photography, at least in Mrs. Cameron's hands, can give us something that only the greatest masters were capable of giving, and they, as we see, were always occupied in giving us so much more that we cannot bother about this.

The England that Mrs. Cameron reveals then was a vigorously individualistic England. It was also given over to art to an extent which we find it hard to understand. Pre-Raphaelitism had leavened the cultured society of the day with an extraordinary passion for beauty. The notion of beauty which obtained had in it always a streak of affectation, it was ensued with a tremendous self-conscious determination. The cult of beauty was a religion and a highly Protestant one, a violent and queasy aversion from the jocular vulgarity of Philistinism. The devotees of this creed cultivated the exotic and precious with all the energy and determination of a dominant class. With the admirable self-assurance which this position gave

them they defied ribaldy and flouted common sense. They had the courage of their affectations; they openly admitted to being 'intense'. In PLATE 22 we get a picture of this strange world. There is something touching and heroic about the naïve confidence of these people. They are so unconscious of the abyss of ridicule which they skirt, so determined, so conscientious, so bravely provincial. It was perhaps a moment when the provincialism of English culture was almost justified by the concentrated effort which it made towards creation, even if the results that emerged now seem to us scarcely adequate. Certainly this 'Rosebud Garden of Girls', as Mrs. Cameron so bravely entitled her plate, revives for us a wonderfully remote and strange social situation. We realize something of the solemn ritual which surrounded these beautiful women. How natural it seems to them to make up and pose like this. They have been so fashioned by the art of the day that to be themselves part of a picture is almost an instinctive function.

Yes, beauty was a serious matter to Mrs. Cameron and her beautiful sitters. But life was altogether serious and earnest, as Longfellow assured them. In that walled-in garden of solid respectability, sheltered by its rigid sexual morality from the storms of passion and by its secluded elevation from the shafts of

ridicule, that pervading seriousness provided an atmosphere wherein great men could be grown to perfection – or rather in which men of distinction could be forced into great men. Look at Longfellow himself, for instance; in that world there is not a doubt but that he was a great man. And what chances would he have to-day? No one of Longfellow's calibre could ever grow to such dimensions or carry himself thus.

In that protected garden of culture women grew to strange beauty, and the men – how lush and rank are their growths! How they abound in the sense of their own personalities! There is Sir Joseph Hooker, a learned and celebrated botanist, but no earth-shaking genius – how superbly he has sprouted in that mild and humid air. Then there was no need to grow defences, no apologies were expected, no deprecating ironies; these men could safely flaunt all their idiosyncrasies on one condition only, that of staying within the magic circle of conventional morality. Browning alone seems to take no advantage of the situation. Was it a deeper sense of life, a knowledge of character which went behind the façades and undermined his own security? He is the least naïve of all. But the Poet Laureate flames out all the more, by comparison, with his too ambrosial locks. How he basks in the genial warmth.

It is curious to note how much the writers and artists are on show. How anxious they are to keep it up to the required pitch. (The numerous photographs of Sir Henry Taylor, which have had to be omitted from the present series, are incredibly diverting in this respect.) And, by comparison, see the supreme unselfconsciousness and simplicity of the men of science: the Herschel, the Darwin, the Hooker – what a pity Huxley is not here. These men alone possessed an unwavering faith which looked for no external support nor approval.

But the women, one may surmise, were more interested in the art which moulded and celebrated them, and Mrs. Cameron was pre-eminently an artist. To return, therefore, to the 'Rosebud Garden of Girls'. It is definitely a Pre-Raphaelite picture, and it is by no means the worst of them. It breaks down here and there it is true. The mass of white of the foremost figure is lacking in shape and definition. It is vague in movement and too unbroken for the rest of the design. The greenery and flowers in the background have come out too tight and minute as compared with the heads which seem to me almost perfect. But, on the whole, how successful a composition it is. It is, however, almost the only case of a group which has come near to artistic success. The albums which Mrs.

Cameron has left contain many attempts to rival the poetical and allegorical compositions which were then in vogue. Watts seems to have been the chief inspiration. We have several 'Annunciations' and 'Holy Families', 'The Kiss of Peace', 'Venus Removing Cupid's Wings', a comparatively harmless operation, for the wings never seem to have adhered very securely – two companion pictures of winged cherubim entitled 'I Wait' and 'I Come'. Then in the Tennysonian vein 'Œnone' and 'Enoch Arden', and, descending to the more pedestrian genre of Maddox Brown, 'Blackberry Gathering'. All these are elaborately arranged and carefully thought out group compositions but, mediocre as the pictures were which Mrs. Cameron sought to rival, it must be admitted that they suffer nothing by the comparison. With the exception of the group reproduced in PLATE 22, these must all be judged as failures from an æsthetic standpoint.

We here touch on one of the most definite limitations of photography used as an art. The chances are too much against success where a complex of many volumes is involved. The co-ordination necessary to æsthetic unity is, of course, only an accident in nature, and while that accident may occur in a single volume such as a human head, which has

its own internal principle of harmony, the chances are immensely against such co-ordination holding for any considerable sequences of volumes, and although the control of the photographic artist may extend to certain things such as the disposition of draperies, he is bound on the whole to depend upon the fortunate accidents of the natural kaleidoscope.

Thus it comes about that we must turn to the portraits to get an idea of how considerable an artist Mrs. Cameron was. For let there be no mistake about it, the unique record of a whole period which these plates comprise is not due merely to the fact of the existence of the camera, it is far more due to the eye of the artist who directed and focussed it. And Mrs. Cameron had a wonderful perception of character as it is expressed in form, and of form as it is revealed or hidden by the incidence of light. Take, for example, the Carlyle [PLATE 10]. Neither Whistler nor Watts come near to this in the breadth of the conception, in the logic of the plastic evocations, and neither approach the poignancy of this revelation of character. And this masterpiece is accomplished by a patient use of all the accidents and conditions of Mrs. Cameron's medium. For the process she employed was far removed from those of modern photography. The wet plates used on this scale needed, I believe,

extraordinarily skilful manipulation and demanded a lengthy exposure. Besides this there were probably imperfections in the lens as compared with modern products. But it was by an exact sense of how to make use of all these accidents that these astonishing results were secured. It may even be that the long exposure, though I believe it meant destroying far more plates than were kept, was, on happy occasions, actually profitable. The slight movements of the sitter gave a certain breadth and envelopment to the form and prevented those too instantaneous expressions which in modern photography so often have an air of caricature. Both expression and form were slightly generalized; they had not that too acute, too positive quality from which modern photography generally suffers.

As an example of the almost complete success possible where a simple volume is taken for the motive we may consider the 'Mary Mother' [PLATE 18]. Here the artist has been able to control everything, the *mise-en-page*, the disposition of the drapery, and the illumination; and the result is almost perfect. No doubt a great painter accepting the data of this would introduce almost unconsciously certain changes. The rhythm of the drapery would have been more completely brought out by slight amplifications here

and retrenchments there, by a greater variety and consistency of accents, and by certain obliterations. In particular the awkward direction of the fold seen in the penumbra behind the profile would have been suppressed or changed, and certain curious accidents in the lighted and shaded portions of the lips would have been modified, but none the less few could have surpassed the beauty of modelling of the left hand side of the face or the exquisite perfection of the contour to the right.

As proof of Mrs. Cameron's right judgment and delicate sensibility and of her fertility of invention examine PLATE 17. How perfectly the diffused and indefinite illumination is suited to bring out all that was significant in the subtle relief of the child's features and the unanalysable rhythm of the oval of her mask. The photograph of Mrs. Herbert Duckworth [PLATE 16], is a splendid success. The transitions of tone in the cheek and the delicate suggestions of reflected light, no less than the beautiful 'drawing' of the profile, are perfectly satisfying.

To return to the men's portraits – both the Herschels [PLATES 1 and 2] seem to me indisputable creations, perfectly distinct, and each the result of an original and definite idea or interpretation of the given data.

Before such works it is impossible to refuse to Mrs. Cameron the title of artist. One cannot doubt that photography's claim to the status of an art would never have been doubted if it had not been that so few artists have ever used the medium. So far as I know Mrs. Cameron still remains far and away the most distinguished.

In this matter our judgments tend to be affected by a widely held idea of some intimate connexion between manual dexterity and artistic power. It requires an effort to shake off altogether the notion that virtuosity is a virtue. The admiring envy and wonder which we feel before an accomplished performance too frequently colours or even determines our admiration of the artist. We forget that an attitude which is perfectly justified before a juggler or an acrobat is entirely irrelevant before an artist. In this connexion Amaury Duval tells a story about Ingres which is significant. No one had a greater right than Ingres, had he chosen to do so, to pride himself on his wonderful virtuosity as a draughtsman. That he valued it as a means to an end is certain, for he used to say to his pupils: 'If you have a hundred pounds worth of skill it is always worth while to buy another halfpennyworth, but', he added, 'you must never show it.' The story is to the effect that when Paganini

came to perform in Paris Ingres took Duval to hear him. In his early days in Rome he used to play the violin with Paganini, and he described to his pupil how great a musician Paganini was, how profound his understanding of the great masters. But many years had elapsed and in the interval Paganini had developed his astonishing powers as a virtuoso, but had also yielded to the seduction of exploiting them. When the first notes were struck Ingres was in ecstasy at the beauty of the tone, but little by little as Paganini began to display his skill at the expense of expression, Ingres' face became more and more clouded, he began to drum with his fingers on the front of the box, and finally he growled out 'Le traître' and hurriedly left the theatre.

The importance usually attributed to manual skill in pictorial art has, I think, prevented hitherto a fair discussion of the position of photography as a possible branch of visual art. We have a natural tendency to put aside any work in which mechanism replaces that nervous control of the hand which alone seems capable of transmitting the artist's feeling to us. We are, I think, quite right to esteem this quality of works of art very highly, but we are wrong to consider it a *sine quâ non* of all artistic expression. With the inevitable growth of mechanical processes in the

modern world we shall probably become increasingly able to concentrate our attention on those elements of artistic expression which do not depend upon this intimate contact at every point of the work with the artist's nervous control, and to disregard those particular qualities in the work which depend exclusively on that. Other qualities undoubtedly remain, such, for instance, as the general organization of the forms within a given rectangle, the balance of movements throughout the whole structure, the incidence, intensity, and quality of the light. In short, all those elements of a picture which we may sum up in the word composition are to some extent independent of the exact quality of the texture at each point.

In any case, Mrs. Cameron's photographs already bid fair to outlive most of the works of the artists who were her contemporaries. One day we may hope that the National Portrait Gallery will be deprived of so large a part of its grant that it will turn to fostering the art of photography and will rely on its results for its records instead of buying acres of canvas covered at great expense by fashionable practitioners in paint.

Overleaf: The Passing of Arthur (William Warder), 1874

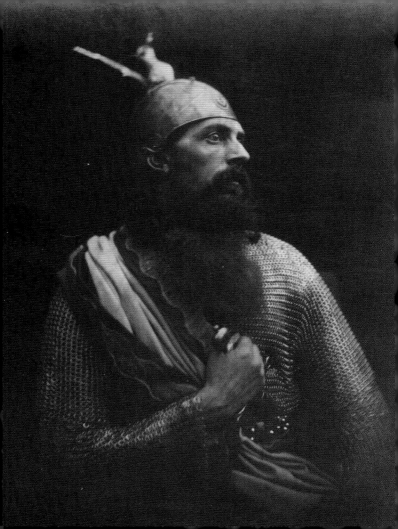

Plates

Plate 1

Sir J. F. W. Herschel
(1792-1871)

Photograph taken April 1867

The only son of Sir William Herschel, the Astronomer Royal, and himself one of the greatest astronomers and scientists of the age. Herschel and Cameron met in South Africa, where he was mapping the stars of the Southern Hemisphere, and they remained close friends for the rest of their lives. 'I remember gratefully that the very first information I ever had of Photography in its Infant Life of Talbotype & Daguerreotype was in a letter I received from you in Calcutta,' she wrote to him. Herschel's interest in photography continued, and he is credited with inventing the terms 'negative' and 'positive' — he may even be the first to have coined the word 'photograph.' He also developed the use of 'hypo.'

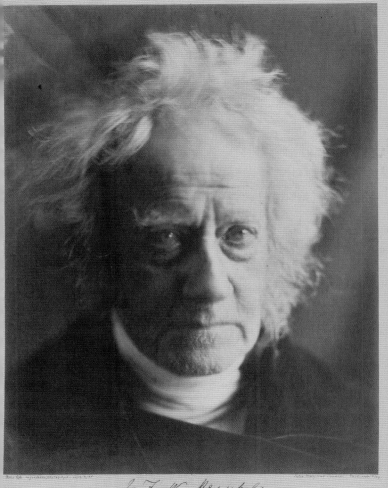

J. F. W. Herschel

Plate 2

Sir J. F. W. Herschel
(1792-1871)

Photograph taken 1867

Written by Cameron on one print of this photograph: 'My revered beloved friend wrote of the Portrait: "that it was the finest he had ever beheld and that it beat hollow everything he had ever seen in photographic art."' She had, unusually, taken her equipment to his house. Herschel's daughter wrote to a friend: 'I hope that she may be more than repaid by the sale of these Portraits at Colnaghi's for the immense cost at which she brought her whole apparatus all the way from Freshwater to Collingwood for the sole purpose of taking Sir John's Portrait. He has promised her (most gladly) never to sit for any other Photographer.'

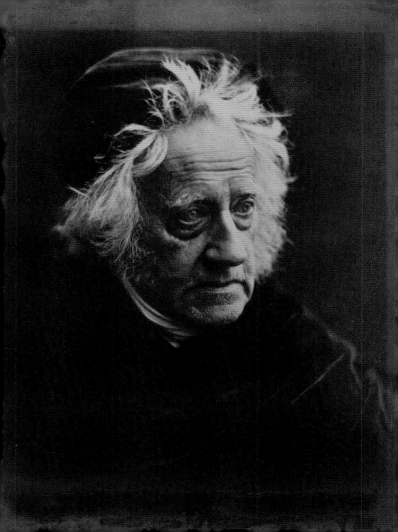

Plate 3

Henry W. Longfellow
(1807-1882)

Photograph taken 1868

The American poet was taken to Mrs. Cameron's studio by Tennyson in 1868. 'Longfellow, you will have to do whatever she tells you. I'll come back soon and see what is left of you.'

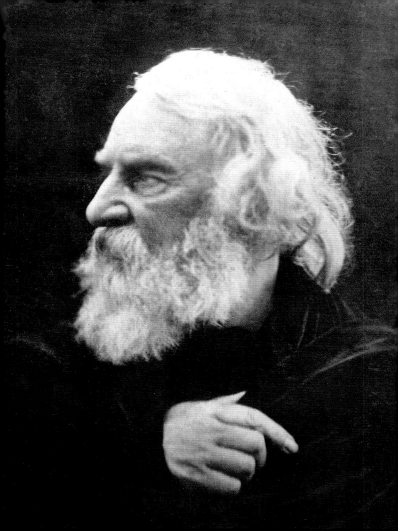

Plate 4

Alfred, Lord Tennyson
(1809-1892)

Photograph taken May 1865
*The dirty Monk: so called by the Laureate
with whom this portrait is a favorite!*

It was William Allingham who said to Tennyson 'They ought to let you go free as a poet.' Tennyson said, 'They charge me double! And I can't go anonymous,' turning to Mrs. Cameron, 'by reason of your confounded photographs.' Allingham also describes tea with Mrs. Cameron and two of her boys: 'Tennyson appeared and Mrs. Cameron showed a small firework toy called "Pharaoh's serpents," a kind of pastille, which, when lighted, twists about in a wormlike shape. Mrs. C. said they were poisonous and forbade us all to touch. T. in defiance put out his hand. "Don't touch 'em!" shrieked Mrs. C. "You shan't Alfred." But Alfred did. "Wash your hands then!" But Alfred wouldn't and rubbed his moustache instead, enjoying Mrs. C's. agonies. Then she said to him, "Will you come tomorrow and be photographed?" He, very emphatically, "No"...' One of Tennyson's complaints was that Mrs. Cameron made bags under his eyes.

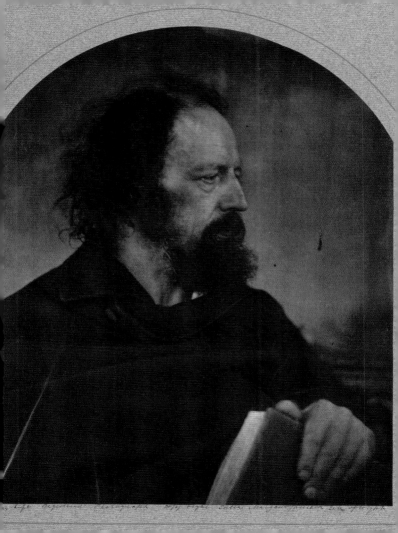

Plate 5

Robert Browning
(1812-1889)

Photograph taken May 1865

The poet was trapped by Mrs. Cameron in the garden at Little Holland House and, as described in *Memorials of Edward Burne-Jones*, 'beguiled into sitting as she would have him, draped in strange wise, and left by her helpless in the folds of the drapery, forgotten for the time as she flew on to some other conquest.'

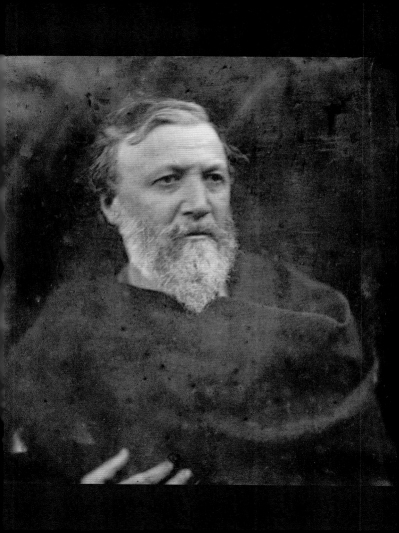

Plate 6

G. F. Watts
(1817-1904)

Photograph taken 1864, probably at the
home of J. E. Millais

'England's Michelangelo'. Watts first met
Mrs. Cameron at the Prinseps' house,
9 Chesterfield Street, before they moved to
Little Holland House. He was a great ad-
mirer of the photographer. 'Quite divine,'
he wrote under one photograph, and 'I wish
I could paint such a picture as this,' under
another. Mrs. Cameron drew great support
from Watts' praise and criticism. He
encouraged her to aim for strong, simple
effects in her portraits. Watts lived in Little
Holland House with the Prinseps and later
built a house at Freshwater, so he had
plenty of opportunity to influence Mrs.
Cameron. This was perhaps not always for
the best on the artistic allegorical side,
which Mrs. Cameron unfortunately devoted
herself to as she became more famous.

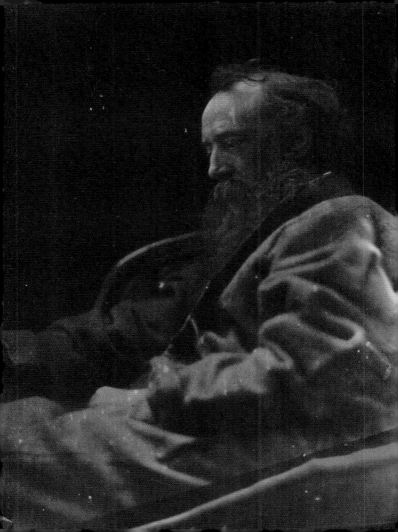

Plate 7

Joseph Joachim
(1831-1907)

Photograph taken 3 April 1868, at the
South Kensington Museum

Hungarian violinist and composer. He played in public at the age of seven, and studied in Vienna and Leipzig, where he was helped by Mendelssohn. He was acclaimed in London in 1844. His most important composition was the Hungarian Concerto, and he was the dedicatee of Brahms's Violin Concerto.

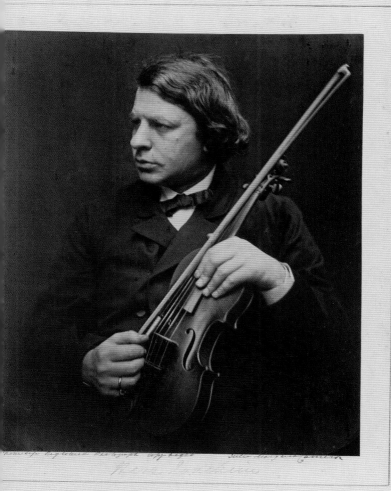

Plate 8

Benjamin Jowett
(1817-1893)

Photograph taken 1865

Master of Balliol College and Regius Professor of Greek at the University of Oxford, where he championed a more historically aware reading of Scripture. At Freshwater he worked on his translation of Plato. Of Cameron he wrote: 'She has a tendency to make the house shake the moment that she enters, but in this dull world that is a very excusable fault.'

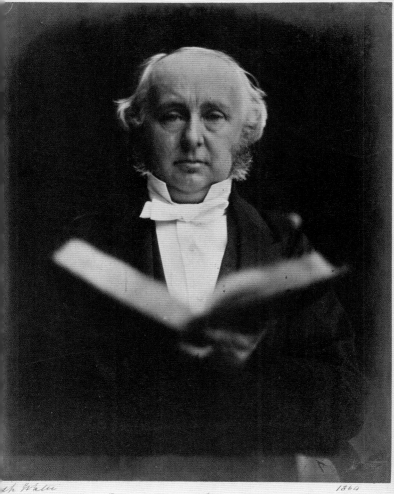

th Water 1864

Professor Jowett

Plate 9

Charles Darwin
(1809-1882)

Photograph taken 1868

Naturalist and founder of the theory of evolution. Darwin was referring to Herschel when he wrote that he intended 'to throw some light on the origin of species — that mystery of mysteries as it has been called by one of our greatest philosophers.' On some copies of this portrait he wrote: 'I like this photograph much better than any other which has been taken of me.' Darwin's work on the *Descent of Man* had been interrupted by illness in 1868, and he had come to Freshwater to recuperate. When he left the Isle of Wight, Mrs. Cameron loaded him with photographs, and his son Erasmus called after her, 'Mrs. Cameron, you have left 8 persons deeply in love with you.'

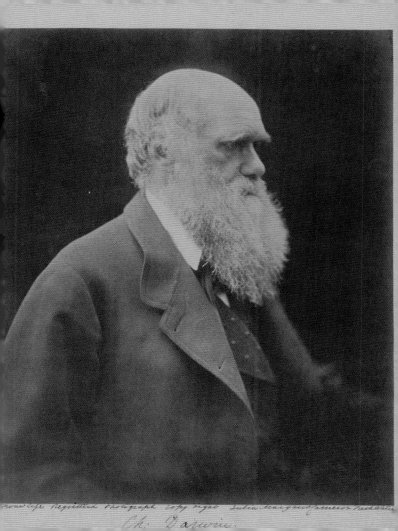

Ch. Darwin

Plate 10

Thomas Carlyle
(1795-1881)

Photograph taken 1867

Essayist and historian. Author of *On Heroes, Hero-worship, and the Heroic in History*; member of the National Portrait Gallery's first board of trustees.

Initially he resisted Cameron, as she complained to the poet Allingham: 'Carlyle refuses to give me a sitting — he says it's a kind of *Inferno*! The *greatest* men of the age (with strong emphasis), Sir John Herschel, Henry Taylor, Watts, say I have immortalised them — and these other men object!! What is one to do — Hm?' However, in 1867 she moved her camera to Little Holland House 'for the sake of taking the great Carlyle'. He later wrote to her, 'Face has something of likeness, though terrifically ugly and woebegone.'

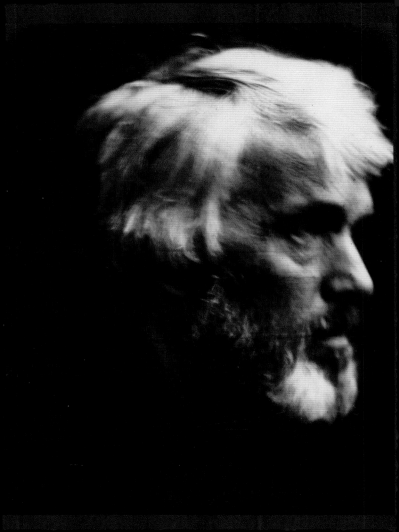

Plate 11

Sir Joseph Dalton Hooker
(1817-1911)

Photograph taken August 1868

One of the greatest scientists and explorers of the age; father of geographical botany. Darwin confided in Hooker his discovery of natural selection: 'I think I have found out the simple way by which species become exquisitely adapted to various ends.' He later called Hooker 'the one living soul from whom I have constantly received sympathy.'

Hooker was director of the gardens at Kew from 1865 to 1885, succeeding his father. Author of, among many other books, *The Student's Flora of the British Isles*.

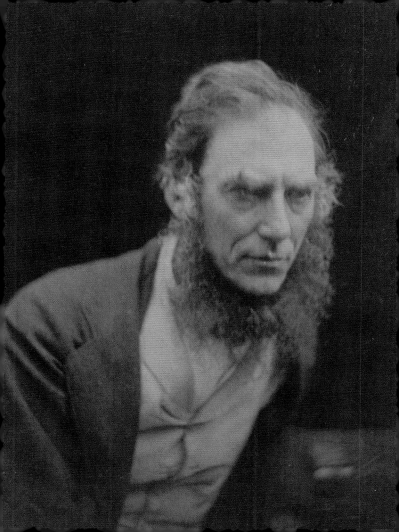

Plate 12

Sir Henry Taylor
(1800-1886)

Photograph taken 1865

Senior civil servant, poet and dramatist. His *Philip van Artevelde*, which was staged by Macready in 1847, was withdrawn after six nights. Sir Henry Taylor had been working on the play for six years. He was Mrs. Cameron's most long suffering model. 'The friend of 38 years and the god-father of my child,' was how she described him. She took many photographs of him, posing (sometimes with the poker) for 'kings, princes, prelates, potentates and peers'. 'I was sent for a week or two every spring and autumn to the Camerons,' he recalled in his memoirs, 'a home, indeed, to which everybody resorted at pleasure, and in which no man, woman or child was ever known to be unwelcome.'

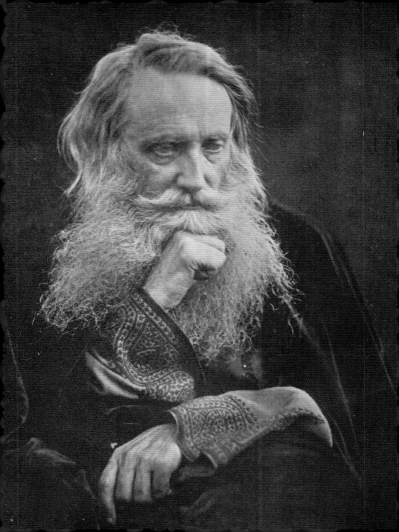

Plate 13

The Hon. Frank Charteris
(1844-1870)

Photograph taken 1867

Eldest son of Lord Elcho, later 10th Earl of
Wemyss. 'A young Paladin', according to
the Tennysons.

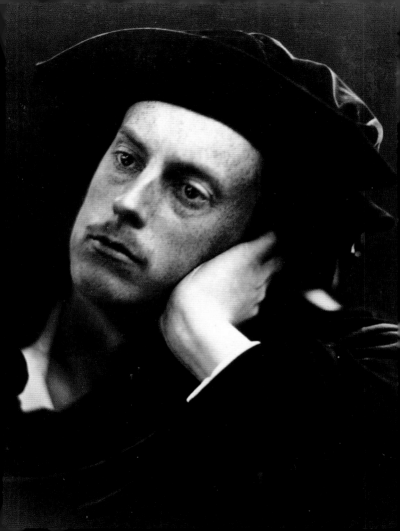

Plate 14

'Sisters'
(Mary and Emily Peacock)

Photograph taken 1873

Little is known about the models for
this composition.

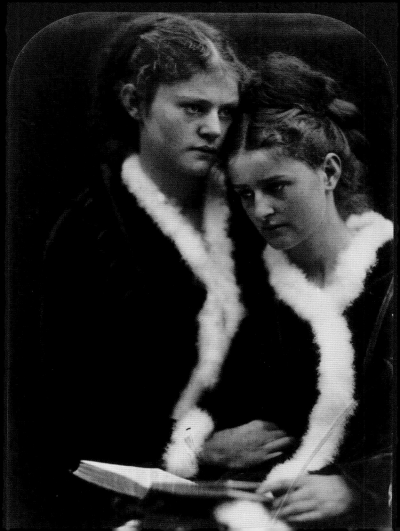

Plate 15

Julia Jackson, Mrs. Leslie Stephen
(Mrs. Herbert Duckworth)
(1846-1895)

Photograph taken 1867

Born in Calcutta, Cameron's god-daughter and the youngest daughter of her sister Maria Jackson. A favourite of Holman Hunt's, she modelled for Watts and Burne-Jones. Her first husband died in 1870 after they had been married three years, leaving her with two infant children and about to give birth to a third. Later she married Leslie Stephen, editor of the *Dictionary of National Biography*, with whom she had four children, including Virginia Woolf and Vanessa Bell.

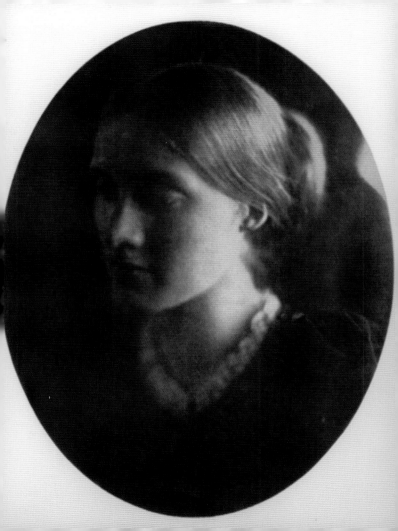

Plate 16

Julia Jackson
(1846-1895)

Photograph taken 1867

Like the previous photograph, this was
probably taken in the weeks before Julia
Jackson's wedding to Herbert Duckworth
in May 1867. The photograph was a best-
seller.

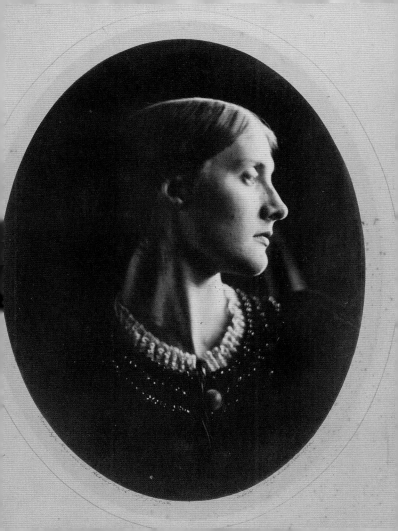

Plate 17

'The Christ Kind'
(Margie Thackeray)

Photograph taken between 1866 and 1869

Margie Thackeray was born in 1863, and
her mother died the following year. She
was adopted by her cousin Anne Thackeray,
daughter of William Makepeace Thackeray
and herself a novelist. Anne's sister Minny
had met her husband, Leslie Stephen, via
Cameron connections; after Minny's death
Stephen became close to Anne's collabora-
tor (and Cameron's niece), Julia Jackson,
marrying her in 1878.

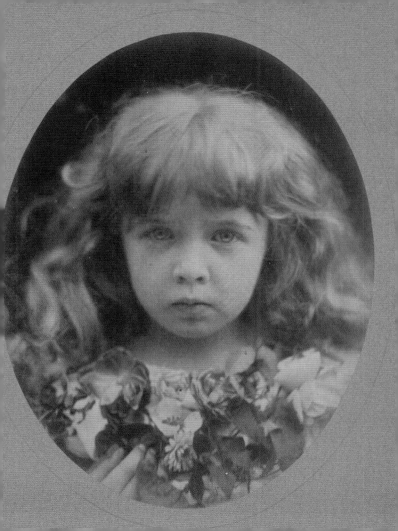

Plate 18

'Mary Mother'
(Mary Hillier)

Photograph taken 1867

Mary Hillier (1847-1936) was the daughter of the local shoemaker; she was Cameron's personal maid from 1861 to 1875 (while her sister worked for the Tennysons). Cameron described her as 'one of the most beautiful and constant of my models'.

Watts called her 'quite divine', and used her features in paintings. After the Camerons left for Ceylon, Mary Hillier married Watts' gardener, Thomas Gilbert, and lived at Watts' Freshwater house. She named her first daughter Julia, after Cameron, and her first son George Frederick, after Watts.

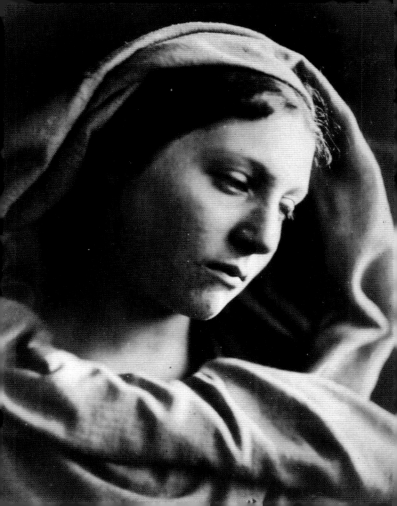

Plate 19

Charles Hay Cameron
(1795-1881)

Photograph taken September 1871

Julia Cameron's husband was the son of the governor of the Bahamas. Trained as a barrister, he was appointed to the Supreme Council of India, where he worked with Macaulay in establishing a code of law for India. He championed the cause of education for Indians.

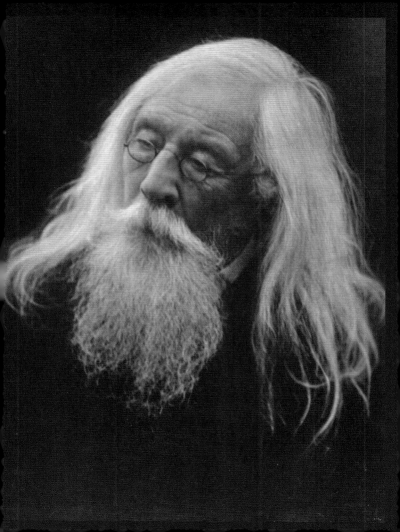

Plate 20

'Sappho'

Photograph taken 1865

Posed by Mary Hillier. Printed from a cracked negative, as she was sometimes obliged to do: 'My most spiritual & glorious head called Christabel is such also,' she wrote to Herschel. 'Mr. Blanchard taught me how to print from those glasses that had suffered.'

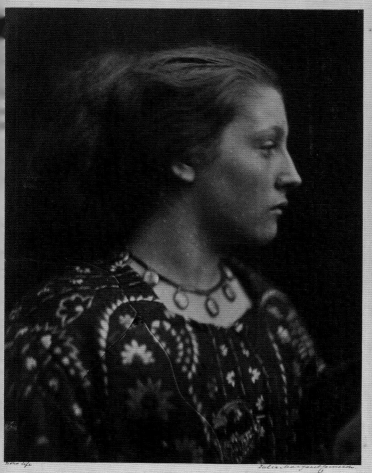

From life

Julia Margaret Cameron

Sappho.

Plate 21

'The Echo'
(Hatty Campbell, born c. 1852)

Photograph taken 1868

Another print of this photograph is inscribed by Cameron, 'And music born of murmuring sound/Shall pass into her face'.

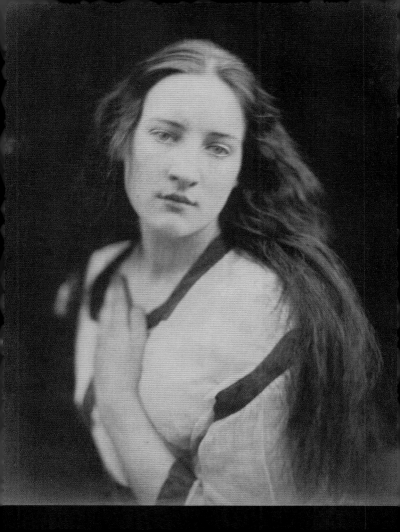

Plate 22

'The Rosebud Garden of Girls'
'Queen rose of the rosebud garden of girls,
Come hither, the dances are done'
Tennyson, Maud

Photograph taken June 1868

Nelly, Christiana, Mary and Ethel were the daughters of Charles Fraser-Tytler, member of a Scottish family of landowners, lawyers and colonial administrators, and friend of Cameron's brother-in-law Henry Thoby Prinsep. Mary (1849-1938), became a portraitist and potter; later married G. F. Watts, wrote his biography and built him the magnificent Watts Memorial Chapel in Compton.

The only one of Cameron's genre pictures that Roger Fry felt he could approve: 'on the whole, how successful a composition it is. It is, however, almost the only case of a group which has come near to artistic success.'

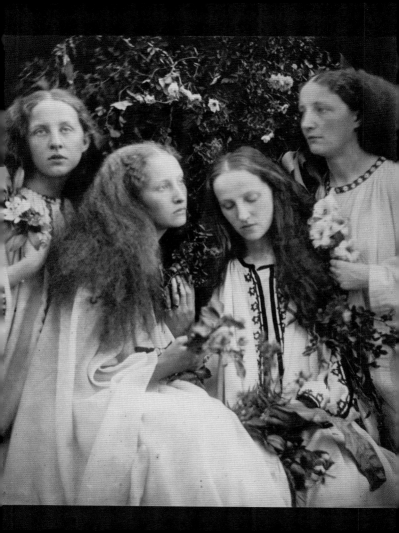

Plate 23

'Paul and Virginia'
(Freddy Gould and Lizzie Keown)

Photograph taken 1864

Freddy Gould (born 1861) was the son of a Freshwater fisherman, and Lizzie 'Topsy' Keown (born 1859) was one of four children of an artillery sergeant stationed nearby on the Isle of Wight, all of whom modelled for Cameron.

The heroes of an eponymous 18th-century novel by Bernardin de Saint-Pierre, Paul and Virginia are shipwrecked as children on Mauritius. They fall in love, but Virginia later drowns, in front of Paul, because her modesty forbids her to remove her clothing. This is one of Cameron's earlier photographs, and she attempted to touch it up, scratching shadows over the boy's foot. The umbrella may have come from Ceylon.

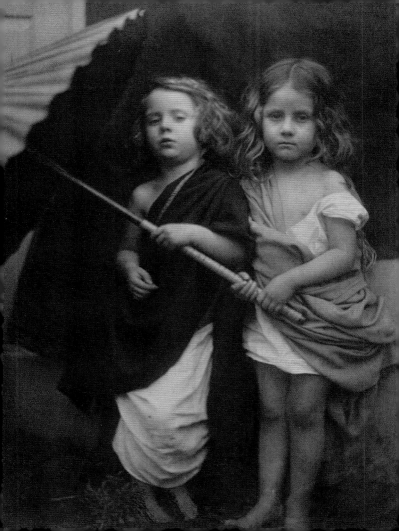

Plate 24

'Florence'
after the manner of the Old Masters

Photograph taken 1872

'I wish I could paint such a picture as this,' commented Watts. Florence Fisher (1863-1920) was the daughter of Herbert Fisher, tutor to the Prince of Wales, who had married Mary Jackson, Mrs. Cameron's niece. They lived at Brockenhurst in the New Forest, close to the Isle of Wight. Florence later married F. W. Maitland, the modern father of English legal history; after his early death she married Francis Darwin, botanist son of Charles. Her daughter remembered 'her menagerie of animals, her hours of violin playing, her feeding of tramps and gypsies, her photography and pony-driving, her story-telling and play-writing'.

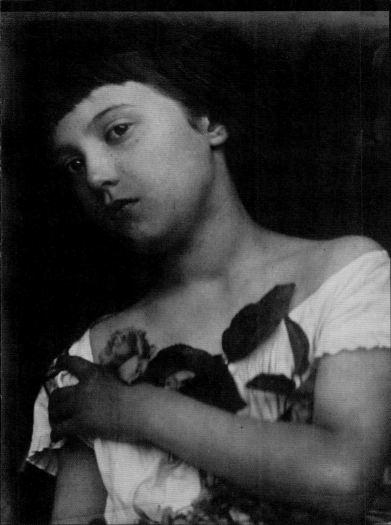

Plate 25

William Gifford Palgrave
(1826-1888)

Photograph taken June 1868

Explorer, spy, sometime Jesuit, diploma-
tist and writer. His *Personal Narrative of a
Year's Journey through Central and Eastern
Arabia* was a bestseller. His brother, Francis
Palgrave, was the editor of *The Golden
Treasury*.

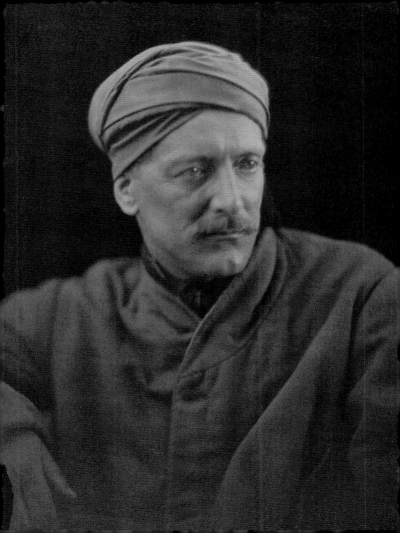

Plate 26

'Sadness'

Freshwater. 17 years old today,
27 Feb 1864

Ellen Terry (1847-1928) was to become the most famous actress of her generation. Oscar Wilde would write, 'No woman Veronese looked upon/Was half so fair as thou whom I behold.' Sarah Prinsep, Mrs. Cameron's sister, had arranged Terry's marriage with G. F. Watts in 1864. The marriage ended unhappily in the following year.

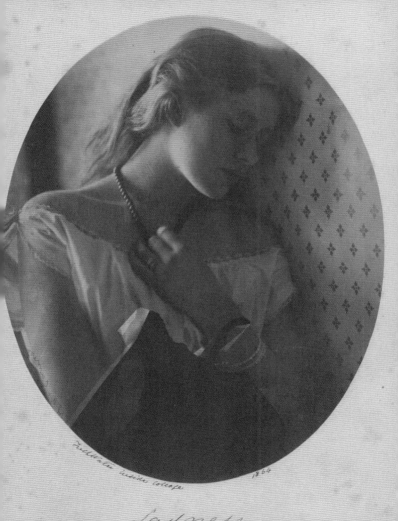

Frederick Hollyer *medium* collotype 1864

Sadness

Plate 27

'Cassiopeia'
(Mrs. Keene)

Photograph taken 1866

Mrs. Keene appears to have been a profes-
sional model who also sat for Burne-Jones.
Henry Taylor's daughter referred to her
as 'Mrs Keane [sic] of beautiful features'.
She was taken as strikingly in an almost
identical photograph entitled *The Mountain
Nymph Sweet Liberty*, about which Herschel
wrote: 'really a most *astonishing* piece of high
relief — She is absolutely alive and thrusting
out her head from the paper into the air.
This is your own Special Style.'

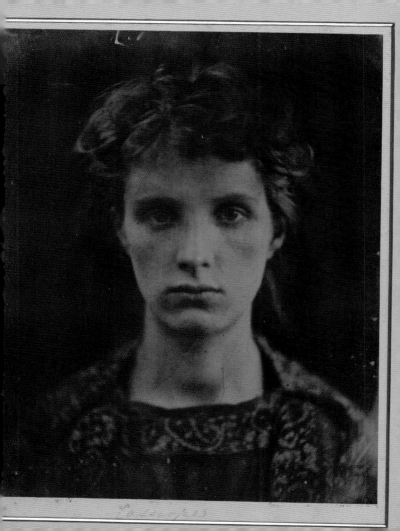

Plate 28

'Madonna with Child'
(Mary Hillier and Percy Keown)

Photograph taken June 1866

Percy Keown (born 1864) was the son of a
soldier on the island.

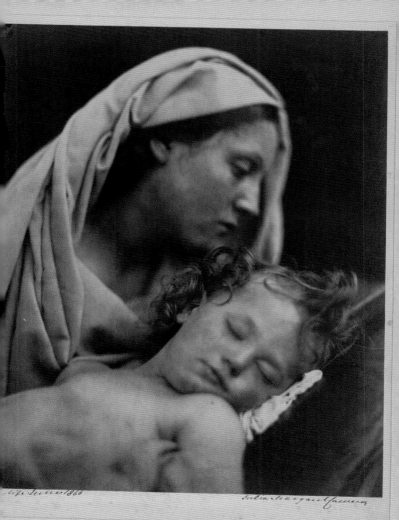

Plate 29

'Summer Days'
(May Prinsep, Freddy Gould,
Lizzie Keown, Mary Ryan)

Photograph taken 1866

Freed from the over-artful influence of the Pre-Raphaelites, Mrs. Cameron's liveliness and sympathy towards her sitters are more apparent.

May Prinsep (1853-1931) was Cameron's niece by adoption and one of her favourite models. She also sat for Watts, and George du Maurier drew her for cartoons in *Punch*. Her second husband was Tennyson's son Hallam, sometime Governor-General of Australia.

Mary Ryan had left Ireland during the famine and was found begging in Putney by Cameron, who took her in, gave her work in the house and had her educated. The year after *Summer Days* was taken she married Henry Cotton, who had first seen her in photographs at Cameron's exhibition; they later moved to India where Henry became chief commissioner of Assam and was knighted.

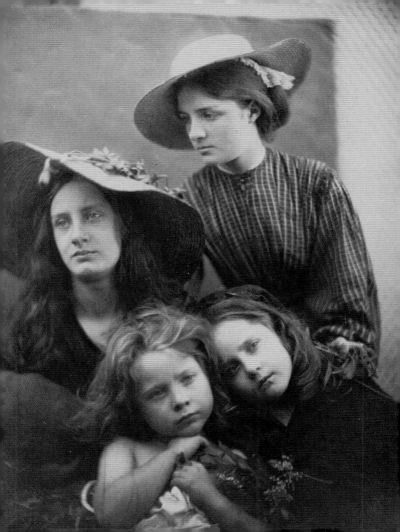

Plate 30

'Mrs. Duckworth at Saxonbury'

Photograph taken August 1872

Cameron's niece Julia Jackson, two years after the death of her husband Herbert Duckworth, with her son George (1868-1934) on her knee, her niece Florence Fisher on the left, and nephew H. A. L. Fisher (1865-1940, historian and Warden of New College, Oxford) on the right. Saxonbury, in Sussex, was her parents' house.

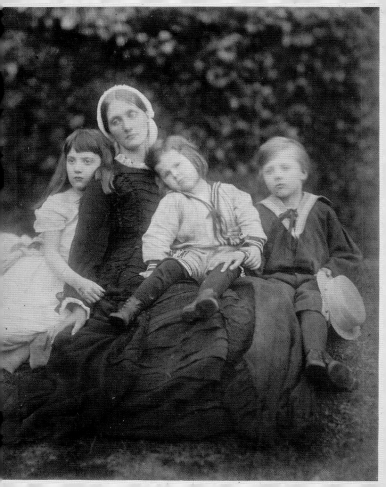

Plate 31

Laura and Rachel Gurney

Photograph taken November 1872

The daughters of Charles Gurney, who was married to Alice Prinsep, Mrs. Cameron's niece. Laura (c. 1867-1946) married Sir Thomas Troubridge, and Rachel (1864-1920), the Earl of Dudley.

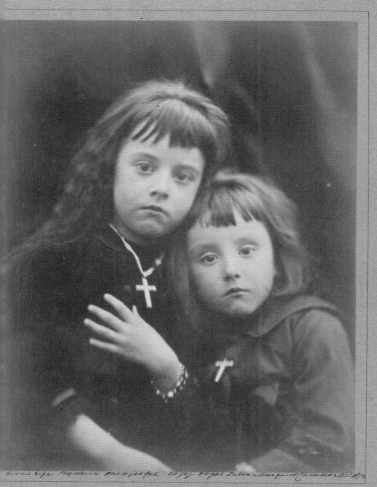

My Nieces Laura and Rachel Gurney

Plate 32

'Elaine Before the King'

Photograph taken 1875

And reverently they bore her into Hall,
Elaine before the King

The series of photographic illustrations to *Idylls of the King* were instigated by Tennyson. He was pleased with the end result and so was Mrs. Cameron. 'It is immortality for me to be bound up with you Alfred,' she wrote. In fact, her narrative photographs have the fatal flavour of amateur dramatics. The model on the left is her husband Charles Hay Cameron, who often could not restrain his laughter during the photographic sessions.

Next to Cameron is William Warder, a porter at Yarmouth Pier. Little is known of the other models.

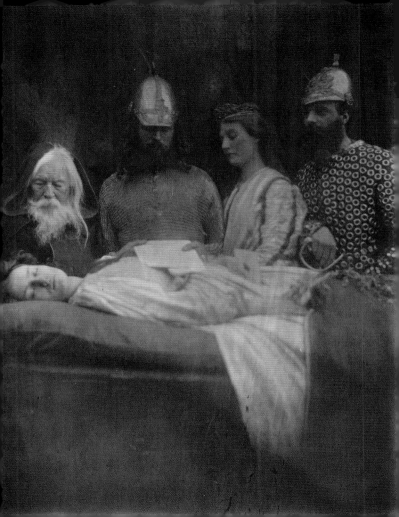

Plate 33

'Pray God Bring Father Safely Home'
(Mary Hillier, Daisy Taylor, unknown
man, Edmund Knight)

Photograph taken May 1874

Three fishers went sailing away to the west,
Away to the west as the sun went down;
Each thought on the woman who loved him the best,
And the children stood watching them out of the town;
For men must work, and women must weep,
And there's little to earn and many to keep,
Though the harbour bar be moaning.

(Charles Kingsley)

On another copy of the photograph, Cameron
wrote: 'The child at her mother's knee praying
for the return of her Father; the little Brother
is standing between the knees of the old grand-
father, who stops mending his net and listens to
you in prayer.'

Edmund Knight was the son of Tennyson's
coachman. Nothing is known of Daisy Taylor.

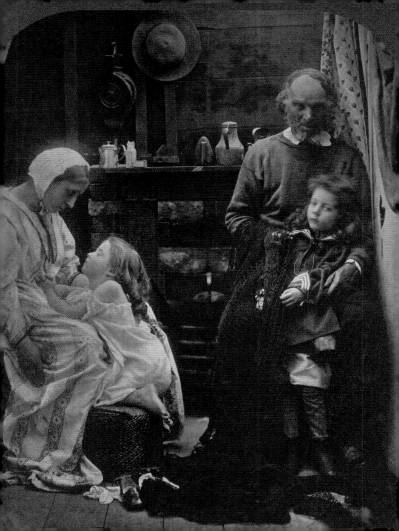

Plate 34

Captain Speedy, Prince Alamayou of Abyssinia and Casa the Servant

Photograph taken July 1868

After the death of the Emperor Theodore of Abyssinia at the Siege of Magdala, Queen Victoria invited Prince Alamayou to stay at Osborne on the Isle of Wight, where he was introduced to Tennyson, through whom Mrs. Cameron arranged to photograph him. The prince was in a highly nervous state and would only sleep in the arms of his guardian Captain (Tristram) Speedy. William Allingham met Prince Alamayou several times. 'Little Alamayou (means "I have seen the world"), Theodore's son, is here at Freshwater, in Speedy's charge, by the Queen's wish. The little prince has a native attendant, a young man, who is devoted to him. Speedy the other day overheard them amusing themselves by mimicking English people. Attendant comes up in the character of an English lady, shakes hand – "How do do?" Alamayou replies "How you do?" Attendant "How you like this country?" Little Prince "Very much." Attendant "Ah you like very much," and so on.'

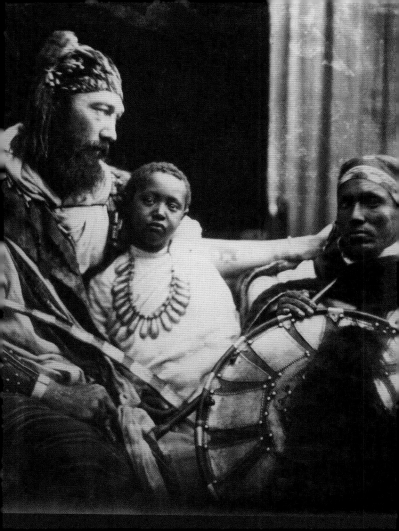

Plate 35

'Study of Child St John'

Photograph taken August 1872,
at Saxonbury

The model is George Duckworth (1868-
1934), later Secretary to the Royal
Commission for Historical Monuments.
Virginia Woolf described him and his
brother Gerald (the publisher) as 'the
demi-gods and tyrants of our childhood.'

Plate 36

'The Minstrel Group'

Photograph taken 1866

*We sing a slow contented song
and knock at Paradise*
(Christina Rossetti)

The models are Mary Ryan, and Katie and
Lizzie Keown. As well as posing, Ryan had
been 'chosen as Mrs. Cameron's general
photographic assistant', as an early com-
mentator noted.

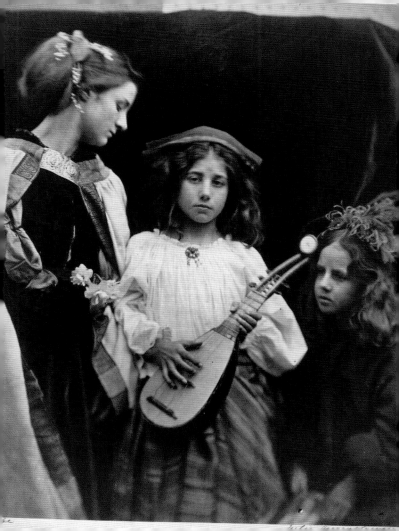

Plate 37

'Christabel'
(May Prinsep at the age of 14)

Photograph taken 1866

Christabel is the innocent heroine of an unfinished poem by Coleridge. She falls into the clutches of a sorceress called Geraldine. 'Her face resigned to bliss or bale—/Her face, oh call it fair not pale/And both blue eyes more bright than blue/Each about to have a tear.' Cameron called this 'my most spiritual & glorious head' and showed a porcelain reproduction of it within a carved box frame at the London International Exhibition in 1872. Herschel was not so sure: 'Christabel is a little too indistinct to my mind, but a fine head.'

This print has been severely trimmed.

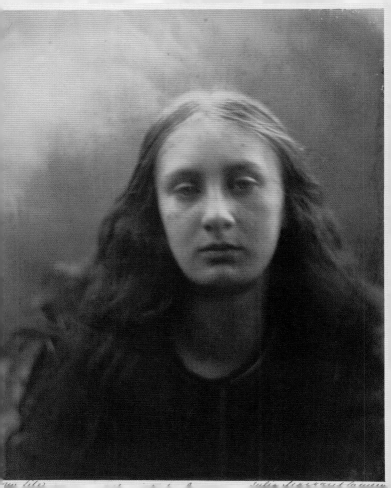

Plate 38

Alfred, Lord Tennyson
(1809-1892)

*Last portrait of Alfred Tennyson,
taken 3rd June 1869*

Edmund Gosse described the life at
Freshwater: 'It was a splendid exclusive
society which circled more or less around
Tennyson. They lived in a radiance of
mutual appreciation. Mrs. Cameron saw
them in a sort of vision, "standing in a cir-
cle in the High Hall, singing with splendid
voices."' Thackeray's daughter Anne, how-
ever, reported another visitor exclaiming:
'Everybody is either a genius, or a poet, or
a painter or peculiar in some way. Is there
nobody commonplace?'

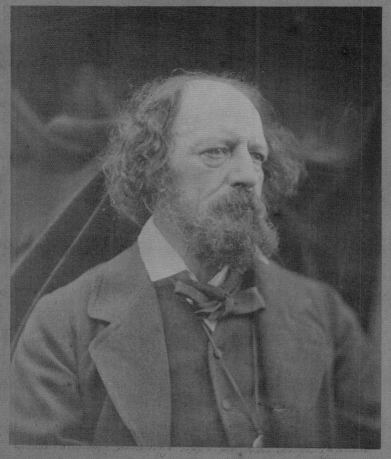

Tennyson

To Mary Anne Perkins

Plate 39

'Madonna'
Julia Norman (1838-1873)

Photograph taken March 1868

Cameron's eldest child and beloved only daughter. She died in childbirth, leaving six children.

Henry Taylor remembered her for her 'entire simplicity and unconscious honesty of mind ... Having been born of parents who were no more ordinary in their ways than in their gifts and faculties and powers, there occurred in the case of the daughter the sort of resilience which is so often observed that it may almost be regarded as a provision of Nature, and her originality took, along with other forms, the form of a determination to be commonplace. Commonplace otherwise than externally she could never be.'

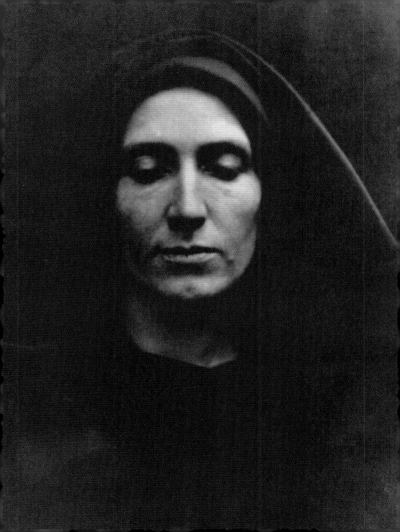

Plate 40

'Beatrice'
(May Prinsep)

Photograph taken 1866

Beatrice Cenci was a 16th-century Roman aristocrat who, tyrannized and raped by her father, conspired with her family to murder him. She is the heroine of a play by Shelley, who has her brother say to her just before the execution: 'Let me/Kiss those warm lips before their crimson leaves/Are blighted—white—cold. Say farewell, before/ Death chokes that gentle voice!' Shelley had been inspired by a portrait then attributed to Guido Reni, on which Cameron based this and a number of other photographs.

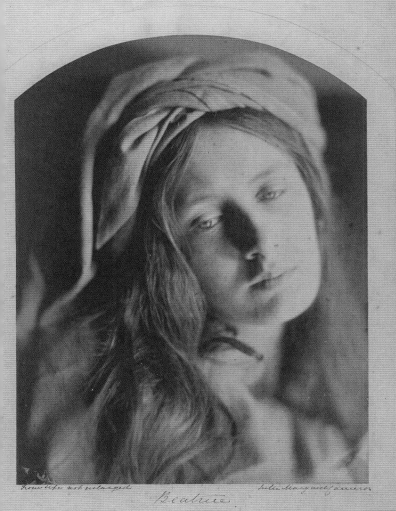

From life not enlarged Julia Margaret Cameron

Beatrice.

Plate 41

Prince Alamayou of Abyssinia
(1861-1879)

Photograph taken July 1868

Charles Darwin's wife Emma wrote: 'Yesterday the little Abyssinian Prince & his Capt. Speedy came to be pho[ed] — they dressed up in Abyssinian dress & we went over to see them.' Allingham remembered the Prince was posed 'in a little purple shirt and a necklace, Captain Speedy in a lion tippet, with a huge Abyssinian sword of reaping hook shape ("point goes into your skull")'.

This print was signed by the prince and inscribed 'King Theodore's Son', in Amharic. Its original owner wrote in the corner: 'Photog. from life. given to me by Mrs. Cameron in a <u>Railway</u> <u>Carriage</u>. August 1868.'

Julia Margaret Cameron.

Photog: from life,
given to me by Mrs Cameron
in a Railway Carriage
August 1868
L.V.Macfingal

Dejatch Alámáyou

�፤ጞ፦ኣለማየሁ።

King Theodore's Son

Plate 42

Lionel Tennyson
(1854-1886)

Photograph taken April 1869

'Lionel Tennyson in the character of Marquis de St Cash as acted in *Payable on Demand* at the private theatricals of the Cameron Thatched House in aid of the Freshwater Village Hospital.'

A participant in another of the plays directed by Cameron recalled that she 'was as severely exacting in this direction as she was in her photography ... though the mischievous Lionel "took it out" not only at rehearsals, but, sad to say, during the public performance of the play by turning his back on the audience and twisting his face into horrible grimaces for the encouragement of the fellow-sufferer who chanced at the moment to be "speaking" his or her "piece"'.

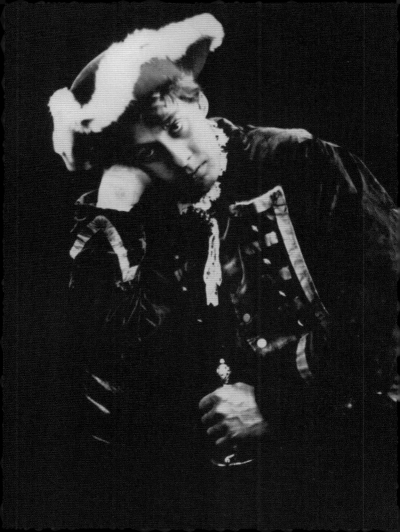

Plate 43

'The Red and White Roses'
(Katie and Lizzie Keown)

Photograph taken 1865

The symbolism is unclear, but red roses can symbolize martyrdom, and white roses purity.

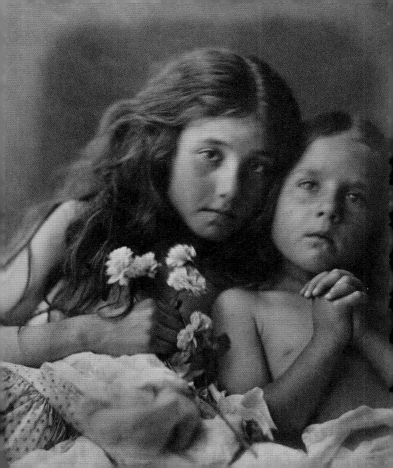

Plate 44

'A Rembrandt'
(Sir Henry Taylor)

Photograph taken 1 June 1865

Other photographs of Henry Taylor in a
similar pose and with the cap are inscribed
'Prospero'.

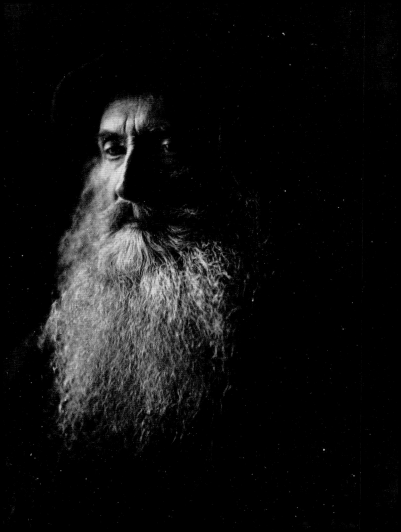

Plate 45

William Holman Hunt
(1827-1910)

Photograph taken 1864

Hunt came to know Cameron at Little Holland House, where he was a visitor at her sister's regular salons, at which Watts was a presiding genius. It was Hunt who designed the wedding dress for Ellen Terry when she married Watts.

He corresponded with Cameron, but noted 'she was perhaps the most perseveringly demonstrative in the disposition to cultivate the society of men of letters and art'. Like many others, Hunt fell under the spell of her niece Julia Jackson, and even proposed marriage.

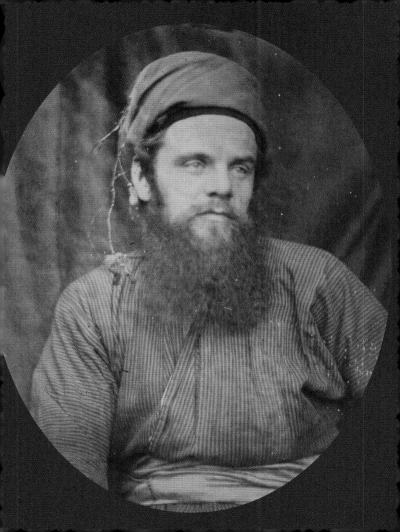

Plate 46

Philip Stanhope Worsley
(1831-1866)

Photograph taken 1866

Worsley died in May 1866 of tuberculosis, not long after this photograph was taken. On February 21 that year Cameron wrote to Henry Cole, director of the South Kensington Museum (now the V&A): 'I have been for 8 weeks nursing poor Philip Worsley on his dying bed – & I have been with him a great part of every day & also a great part of the night. The heart of man cannot conceive a sight more pitiful that the outward evidence of the breaking up of his whole being.'

Worsley was a poet who translated Homer into Spenserian verse. The obituarist of the *Athenæum* called him 'the most perfect model of a Christian gentleman.'

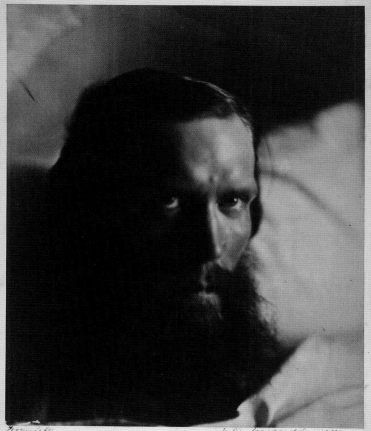

Philip Stanhope Worsley

Plate 47

'I wait'
(Rachel Gurney)

Photograph taken 1872

In later life Laura Gurney recalled: 'Rachel and I were pressed into the service of the camera. Our roles were no less than those of two of the angels of the Nativity, and to sustain them we were scantily clad, and each had a pair of heavy swan's wings fastened to her narrow shoulders, while Aunt Julia, with ungentle hand, tousled our hair to get rid of its prim nursery look. No wonder those old photographs of us, leaning over imaginary ramparts of heaven, look anxious and wistful. This is how we felt, for we never knew what Aunt Julia was going to do next, nor did anyone else... All we were conscious of was that once in her clutches, we were perfectly helpless.'

This print belonged to Virginia Woolf, and later to Robert Mapplethorpe.

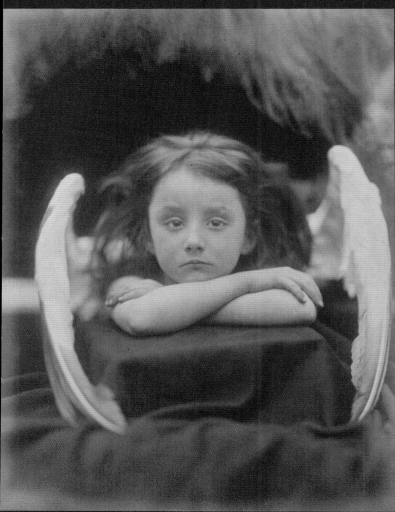

Plate 48

The children of Charles and
Julia Norman:
George Jr., Archie, Charlotte and Adeline

Photograph taken c. 1870-72

Cameron took many photographs of her
grandchildren by her much-loved daughter
Julia, who died in childbirth in 1873.
Charlotte Norman later married William
Boyle, the brother of Hallam Tennyson's
first wife.

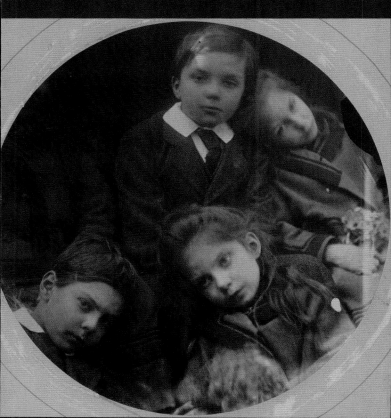

Plate 49

May du Maurier
(1868-1934)

Photograph taken 1874

The draughtsman and novelist George du
Maurier recalled his favourite daughter in
his novel *The Martian* (1896): "Unlike her
brothers and sisters, she was a studious
little person, and fond of books – too much
so indeed, for all she was such a tomboy...
in temper and sweetness of disposition the
child was simply angelic and could not be
spoiled by any spoiling."

Of Cameron, he wrote: "[she] is without
exception the greatest character I ever met;
I find her delightful but don't think she
would suit as a permanent next door neigh-
bor for the next 30 years or so unless one
could now & then get away. She is going
to photograph May – also the Missus – also
me. She says I have a fine head (I had always
suspected this)."

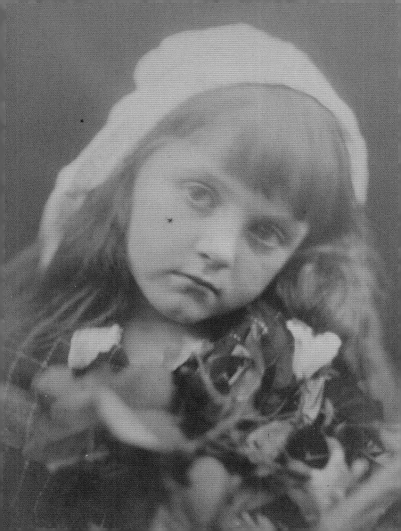

Plate 50

The Kiss of Peace
(Florence Anson? and Mary Hillier)

Photograph taken 1869

Florence Anson was the daughter of the
Earl of Lichfield and grand-daughter of the
Duke of Abercorn.

Another print of this photograph was
inscribed by Cameron: 'Dearest Charlie I
give you this prize copy of the most beauti-
ful of all my photographs. This is a very
splendid print so like a sepia painting that
it is difficult to believe that it is genuine
untouched photography but being perfect
in its way it becomes a little worthy of
you who has so much of my trust love and
Gratitude. Day of farewell Oct 18th. '78
Julia Margaret Cameron'.

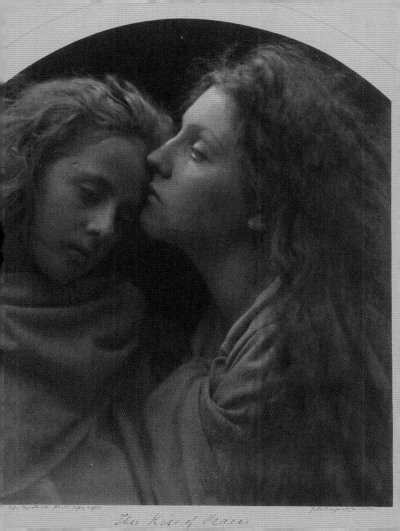

The Kiss of Peace

LIST OF ILLUSTRATIONS AND PLATES

All works albumen silver prints unless stated otherwise
CF numbers refer to the catalogue raisonné established by Julian Cox and Colin Ford,
Julia Margaret Cameron: The Complete Photographs
(*Getty Publications*, 2003)

LIST OF ILLUSTRATIONS AND PLATES

p. 58, 'Maud' (Mary Hillier), 1875, CF 1195, 32.9 x 27.1 cm,
J. Paul Getty Museum, Los Angeles
p. 63: Thomas Carlyle, 1867, CF 627, 36.7 x 25.9 cm,
J. Paul Getty Museum, Los Angeles
p. 68: 'Zoe, Maid of Athens' (May Prinsep), 1866, CF 392, 30.1 x 24.5 cm,
The Metropolitan Museum of Art, New York
p. 72: 'The Princess' (Miss Johnson, Miss Johnson, unknown woman, Mary Hillier),
1875, CF 1181, 31.6 x 25.2 cm, J. Paul Getty Museum, Los Angeles
p. 86: 'The Passing of Arthur' (William Warder), 1874, CF 1175, 35.2 x 26 cm,
J. Paul Getty Museum, Los Angeles

PLATES
Plate 1: Sir J. F. W. Herschel, April 1867, CF 675, 35.4 x 27.3 cm,
J. Paul Getty Museum, Los Angeles
Plate 2: Sir J. F. W. Herschel, April 1867, CF 674, 27.9 x 22.7 cm,
J. Paul Getty Museum, Los Angeles
Plate 3: Henry W. Longfellow, 1868, CF 712, platinum print, 24.4 x 17.4 cm,
George Eastman House, New York
Plate 4: Alfred, Lord Tennyson, 1865, CF 796, 25.9 x 21.1 cm,
J. Paul Getty Museum, Los Angeles
Plate 5: Robert Browning, May 1865, CF 589, 21.8 x 21.8 cm,
J. Paul Getty Museum, Los Angeles
Plate 6: G. F. Watts, 1864, CF 826, 27.3 x 21 cm,
The National Museum of Photography, Film and Television, Bradford
Plate 7: Joseph Joachim, 3 April 1868, CF 695, 29.5 x 24.3 cm,
The Metropolitan Museum of Art, New York
Plate 8: Benjamin Jowett, 1865, CF 698, 26.5 x 21.6 cm,
J. Paul Getty Museum, Los Angeles
Plate 9: Charles Darwin, 1868, CF 645, 28.5 x 22.7 cm,
The Harry Ransom Center, Austin TX
Plate 10: Thomas Carlyle, 1867, CF 629, 30 x 24.1 cm,
J. Paul Getty Museum, Los Angeles
Plate 11: Sir Joseph Dalton Hooker, August 1868, CF 680, 31.9 x 26.8,
J. Paul Getty Museum, Los Angeles
Plate 12: Sir Henry Taylor, 1865, CF 783, carbon print, 25.5 x 20.1 cm,
Victoria and Albert Museum, London
Plate 13: The Hon. Frank Charteris, 1867, CF 632, 32.7 x 26.5 cm,
The National Museum of Photography, Film and Television, Bradford
Plate 14: 'Sisters' (Mary and Emily Peacock), 1873, CF 374, 36.5 x 25.3 cm,
The Wilson Centre for Photography, London

LIST OF ILLUSTRATIONS AND PLATES

Plate 15: Julia Jackson (to become Mrs. Herbert Duckworth;
later Mrs. Leslie Stephen), 1867, CF 312, 33.8 x 26.2 cm, Art Institute of Chicago

Plate 16: Julia Jackson (to become Mrs. Herbert Duckworth; later Mrs.
Leslie Stephen), 1867, CF 311, 34.1 x 26.2 cm, J. Paul Getty Museum, Los Angeles

Plate 17: 'The Christ Kind' (Margie Thackeray), 1866-69, CF 1043, 34.3 x 26.3 cm,
The Harry Ransom Center, Austin, TX

Plate 18: 'Mary Mother' (Mary Hillier), 1867, CF 101, 30.7 x 25.7 cm,
The National Museum of Photography, Film and Television, Bradford

Plate 19: Charles Hay Cameron, 1871, CF 599, carbon print from copy negative,
31.5 x 24.5 cm, Victoria and Albert Museum, London

Plate 20: 'Sappho' (Mary Hillier), 1865, CF 253, 34.4 x 26.1 cm,
The Metropolitan Museum of Art, New York

Plate 21: 'The Echo' (Hatty Campbell), 1868, CF 181, 27.1 x 22.7 cm,
J. Paul Getty Museum, Los Angeles

Plate 22: 'The Rosebud Garden of Girls' (Nelly, Christiana, Mary and Ethel Fraser-
Tytler), June 1868, CF 1125, 29.4 x 26.7 cm, J. Paul Getty Museum, Los Angeles

Plate 23: 'Paul and Virginia' (Freddy Gould and Lizzie Keown), 1864, CF 23,
25.4 x 19.8 cm, J. Paul Getty Museum, Los Angeles

Plate 24: 'Florence' (Florence Fisher), 1872, CF 950, 34 x 25.6 cm,
J. Paul Getty Museum, Los Angeles

Plate 25: William Gifford Palgrave, June 1868, CF 733, 33.7 x 26.2 cm,
J. Paul Getty Museum, Los Angeles

Plate 26: 'Sadness' (Ellen Terry), 27 February 1864, CF 496/7, carbon print,
13.7 x 9.6 cm, Victoria and Albert Museum, London

Plate 27: 'Cassiopeia' (Mrs. Keene), 1866, CF 339, 34.9 x 27.4 cm,
The Metropolitan Museum of Art, New York

Plate 28: 'Madonna with Child' (Mary Hillier and Percy Keown), June 1866,
CF 136, 33 x 27.5 cm, The Harry Ransom Center, Austin, TX

Plate 29: 'Summer Days' (May Prinsep, Freddy Gould, Lizzie Keown, Mary Ryan),
1866, CF 1096, 35.3 x 28.2 cm, National Gallery of Art, Washington, D.C.

Plate 30: 'Mrs. Duckworth at Saxonbury' (Florence Fisher, Julia Duckworth,
George Duckworth, Herbert Fisher), August 1872, CF 322, 34.9 x 28.6 cm,
Museum of Fine Arts, Boston, MA

Plate 31: Laura and Rachel Gurney, 1872, CF 962, 32.7 x 24.9 cm,
The Rijksmuseum, Amsterdam

Plate 32: 'Elaine Before the King' (Charles Hay Cameron, William Warder,
Mrs. Hardinge, unknown man, unknown woman), 1875, CF 1191, 34.6 x 28.4 cm,
J. Paul Getty Museum, Los Angeles

Plate 33: 'Pray God Bring Father Safely Home' (Mary Hillier, Daisy Taylor,
unknown man, Edmund Knight), May 1874, CF 1154, carbon print,
37.8 x 29.5 cm, J. Paul Getty Museum, Los Angeles

With thanks to the J. Paul Getty Museum and to other holding institutions for all plates and illustrations except plates 14, 15, 34, 39 (Tristram Powell), plates 3, 6, 13, 14, 18, 42 (Wikimedia), and p. 9 (Google Art Project)

© 2016, 2018 Pallas Athene

Published in the United States of America in 2018 by the J. Paul Getty Museum, Los Angeles
Getty Publications
1200 Getty Center Drive, Suite 500
Los Angeles, California 90049-1682
www.getty.edu/publications

Distributed in the United States and Canada by the University of Chicago Press

Printed in China

ISBN 978-1-60606-580-8
Library of Congress Control Number: 2018936722

Published in the United Kingdom by Pallas Athene (Publishers) Ltd.,
Studio 11A, Archway Studios
25–27 Bickerton Road, London N19 5JT

Alexander Fyjis-Walker, *Series Editor*
Patrick Davies and Anaïs Métais, *Editorial Assistants*

Front cover: Henry Herschel Hay Cameron, *Julia Margaret Cameron*, 1874. Albumen silver print, 25.4 x 21.4 cm (10 x 8 7⁄16 in.). Los Angeles, J. Paul Getty Museum, 86.XM.637.1

Editor's Note
Victorian Photographs of Famous Men and Fair Women by Virginia Woolf and Roger Fry was first published in 1926 by the Hogarth Press. An enlarged edition with a new preface was edited by Tristram Powell and published by the Hogarth Press in 1973. This edition incorporates "Annals of a Glass House" and "On a Portrait" by Julia Margaret Cameron, and further plates and illustrations, together with an updated introduction and captions. Grateful thanks to Tristram Powell for his assistance and use of material from the introduction and captions of the 1973 edition. Since that was written a great deal of new information has emerged, much of it presented in *Julia Margaret Cameron: The Complete Photographs* by Julian Cox and Charles Ford (Getty Publications, 2003), which is recommended to any reader wishing to explore Cameron's work further.